Painting *with* Light

LIGHTING & PHOTOSHOP® TECHNIQUES FOR PHOTOGRAPHERS

ERIC CURRY

AMHERST MEDIA, INC. ■ BUFFALO, NY

Published by:
Amherst Media, Inc.
P.O. Box 586
Buffalo, N.Y. 14226
Fax: 716-874-4508
www.AmherstMedia.com

Publisher: Craig Alesse
Senior Editor/Production Manager: Michelle Perkins
Assistant Editor: Barbara A. Lynch-Johnt
Editorial Assistance from: Carey A. Miller, Sally Jarzab, John S. Loder
Business Manager: Adam Richards
Marketing, Sales, and Promotion Manager: Kate Neaverth
Warehouse and Fulfillment Manager: Roger Singo

ISBN-13: 978-1-60895-504-6
Library of Congress Control Number: 2012936501
Printed in The United States of America.
10 9 8 7 6 5 4 3 2 1

Check out Amherst Media's blogs at: http://portrait-photographer.blogspot.com/
http://weddingphotographer-amherstmedia.blogspot.com/

Table of Contents

About the Author .6

To My Three Fathers .7

Preface .8

Introduction .9

My History .10

Real-World Clients and Jobs14

Photography: A Brief History16

Traditional Night Photography18

Painting with Light: Single-Exposure Approaches20

Painting with Light: Multiple-Exposure Approach23

Create, Don't Copy .26

1. Logistics (Camera, Lights, and Other Tools) .28

Cameras: Almost Any Digital Camera Will Work28

Manual Shutter .28

Manual Focus .29

Manual White Balance .29

Optical Viewfinder .29

Lenses: The Best Focal Length for the Job29

Lights: Which Lights to Use33

Smaller Scenes .33

Larger Scenes (and Not-Quite-Dark Environments)34

Snoots: Shielding the Light from Splashing Everywhere37

Tripods: Stability Is Key .38

A Cable Release .39

Spare Batteries. .40

Portable DVD Player or Laptop for Screen Display40

Painter's Poles for Holding Lights42

Plugs, Switches, and Extension Cords43

Plan for Comfort. .44

Keep It Simple: A Final Thought on Logistics44

2. Preparing for the Shoot46

Scouting the Location in Advance46

Qualities that Make a Good Subject and Scene.48

 A Subject with Mass .49

 An Interesting Environment49

 A Dark Environment. .50

For More Ambitious Projects, Ask Permission53

3. The Shoot .57

Set Up in Daylight and Wait57

Basic Camera Settings .60

 Noise Reduction .60

 White Balance .60

 File Format .62

 ISO Setting. .63

 Aperture Setting . 63

 Focusing. .64

Begin Shooting .66

 Don't Move the Tripod or Camera After You Start66

 Shoot the Whole Scene .67

 Capture the Sunset .69

Exposure .70

 Charts, Graphs, Exposure Tables,

 and Formulas? Skip It!70

 What's "Right" Is Subjective72

 Making Basic Exposures73

Shutter Operation .76

Lighting the Subject and Environment.78

 Have a Lighting Plan. .79

 Work on Small Sections.81

Try Some Variations .81

Lighting the Overall Scene85

Stand to the Side. .88

Hard Light and Soft Light.89

The Mechanics of Exposing Everything98

Include All Existing Light Sources105

Get Physical, Stay Focused. .106

4. Adding Human Subjects109

People Move! .109

Design a Stable Pose .110

Light in a Single, Smooth Pass. .113

Lighting People with Strobes. .115

Postproduction .116

5. Postproduction. .117

Image-Editing and Management Software117

Using Photoshop to Recombine the Images.120

Creating the Layers .120

Using Photoshop to Recombine People

(Dr. Frankenstein) .126

6. Practical Examples.130

Corvette .130

Yellow Submarine .138

Airstream Trailer .146

B-25 Bomber. .151

Conclusion. .156

APPENDIX: A Quick-and-Dirty Review157

Index .158

About the Author

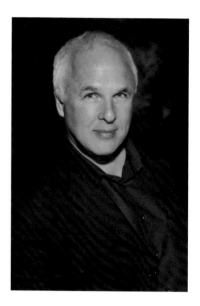

Eric Curry was born in Los Angeles, vintage 1956. He was raised on sugary breakfast cereals and Saturday morning cartoons—with healthy doses of *Gilligan's Island* reruns thrown in for good measure. Graduating the public schools system with a solid C grade-point average, he was clearly destined for greatness . . . or at least a career in the visual arts.

After completing the curriculum from Art Center College of Design in 1980 with a BA in photography, Eric moved to Copenhagen, Denmark, where he ran his own advertising photography studio for over ten years. There, he worked with the largest agencies in the country, shooting brands such as Novo, Bang & Olufson, Pfizer, Maersk Line Shipping, LEGO, and Philips Electronics.

Upon returning to the States in 1992, Eric gradually transitioned to location industrial photography, because it afforded, as he comments, "a much broader palette of avenues for creativity."

After thirty years of shooting as a professional, and an additional five years working on the series *American Pride and Passion*, Eric is now sharing the secrets of how some of his most effective shots were made—and how you can make similarly powerful photographs yourself.

Currently, Eric creates photographs exclusively on location for select clients and himself, taking full advantage of the depth and possibilities afforded by each and every new challenge.

To My Three Fathers

To my dad. Your passing, while I was still just a kid starting high school, robbed us of the chance to know each other as men. That loss of your presence, so well-tempered now after these many years, has softened further in my hope that you would have been proud of your youngest son. The passion and creativity you brought to the world of industrial design has inspired me on my own journey of commercial photography and this art series specifically. I flatter myself further in thinking that even a quarter of your creativity could be coursing through my veins. Although we will never meet as men, father and son sharing together, please accept this gift I present as a statement of what your son has become.

To my step-dad, Myron. Joining our family over thirty-five years ago—Mom with her four rebellious teenage kids—could not have been easy. As a young person, your consistent encouragement and support meant the world to me. Taking on the added burden, both financially and emotionally, of supporting my decision to attend a very expensive private photography college was generous beyond measure. I will be eternally grateful. Our family is so much richer since the day you walked into our lives. It has been said before, but one more time for the record seems appropriate: thank you so much for a life-long career and the passion I am so fortunate to experience every day of my life. Love, your son Eric.

To my father-in-law, Kazuo "Kaz" Takahashi. My marriage to your daughter and the simultaneous discovery of your cancer diagnosis, followed less than a year later by your death, made for a sad and difficult experience with my new extended family. I can't really say I knew you well, but maybe I understood you to a small degree. Having been a farmer your whole full life, and coming from the older generation of Japanese Americans, among whom dignified silence is an appropriate expression of integrity, you demonstrated character and strength through quiet resolve. Lacking eloquence of speech, it was my feeble attempt to poetically chronicle your life well-lived by photographing the implements of your trade—sixty years of used tractors scattered about the farm—that started me down this path, a visual journey that has been so rich and fulfilling. I intuitively understand, but cannot fully explain in words, this last gift you have given me. Maybe these photographs could speak for themselves.

Preface

This book is a practical and inspirational resource demonstrating the photographic techniques and creative concepts of painting with light. Written in plain language, and with the inclusion of over 250 photos and illustrations, it will show photographers, from amateur to professional, how I created the works illustrated herein. You will see how you too can easily create your own amazing painting-with-light photos. This technique is not hard and only requires a short leap of imagination that has not been revealed previously. You will quickly grasp not only the mechanics of painting with light, but easily come to understand the philosophy I employ in order to create spectacular photographs from seemingly mundane subject matter.

This technique is not hard and only requires a short leap of imagination . . .

Introduction

I n this book, I will demonstrate the simple techniques and concepts involved in painting with light, as well as how to combine multiple light-painted exposures into a single wonderful photograph. More than that, it is my intention to open a door in your mind's eye and allow you to truly see—for perhaps the first time. For those of you who are students, whether in school or in the broader sense of the word (people who want to expand their knowledge base and learn something new), this book will be a wild ride of cutting-edge photography concepts and techniques. Happily, these are now accessible to everybody, not just the elite

This vintage Airstream trailer was photographed in Hesperia, CA, using my painting-with-light technique (over the course of four hours), multiple exposures, and several large flashlights. In the last chapter of this book, we'll review the whole sequence of images involved in creating this image.

few with ultra-expensive cameras and mountains of hardware. Anybody can do this!

As a photographer, it is up to you as a person with vision to reveal truths about our world, allowing others to finally see what you imagined before your photograph was created. I want to give you not only the tools to make amazing photographs but also an understanding of the philosophy involved in crafting your own master works of art. If I can inspire you in your own endeavors to create and share with viewers, then this book will have been successful.

It is up to you as a person with vision to reveal truths about our world . . .

My History

I have been a professional photographer for over thirty years (wow, I'm feeling older already!). As a student at the Art Center College of Design in Pasadena, CA, I discovered that—because they don't move about—I enjoyed photographing table-top products more than living, breathing models. Composing and lighting "things" was far more fulfilling, because it was easier to make an absolutely precise photograph. Trying to create the same level of precision in my lighting with a somewhat pampered live model was a challenge

BELOW AND FACING PAGE—These shots were created during my college days—shooting fake advertising images was part of my passion back then. I always tried to create something that was precise and visually different by displaying objects to the viewer in an unusual or dynamic way.

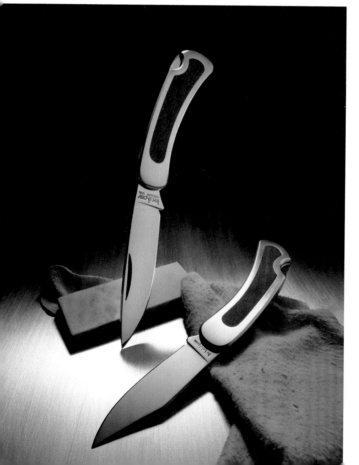

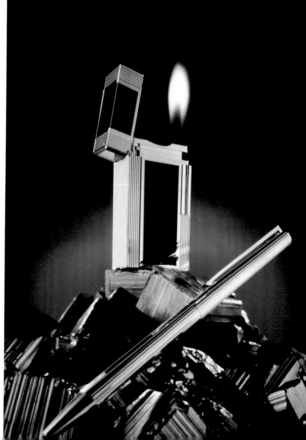

for me. What motivated me then, and still does to this day, is the challenge of trying to achieve something new and visually striking.

Given that I naturally gravitated toward still-life scenes and special effects (glowing cans of soup and flying stereos shot in my photo studio), it was no surprise that I eventually transitioned to industrial photography (on-location shoots with jet aircraft and heavy industrial equipment). In those days, before the advent of high-resolution digital photography, I employed complex multiple-exposure techniques to achieve the look I sought. At the time, I was living in Copenhagen, Denmark. It was not unheard of for me to employ four or five different large-format cameras and move the film sheet from camera to camera in order to build up a single finished image from a careful sequence of different exposures. The

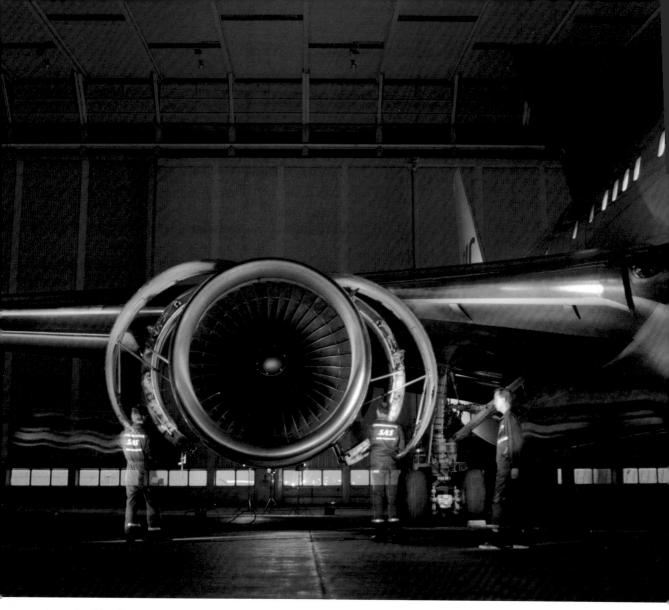

final look was pretty slick, and it was all done without having to rely on photo-retouching laboratories. Even then, more years ago than I care to think about, I was using the techniques of painting with light on small and sometimes very large subjects (the photograph of Scandinavian Airlines jets shot in the hangars of Copenhagen is one example).

When I finally began my quest to create a series of artistic images at night, using all that I had learned over the previous thirty years, my reach was modest. It was initially my hope to tell simple stories in these images—but over time, my desire to present ever-more-elaborate narratives in my images grew. And as the stories

ABOVE AND FACING PAGE—The photograph of the SAS jet was shot using paint-with-light techniques and traditional strobe pops to illuminate the cavernous interior of the hangar. The other shots (Pernod underwater, medicine, and Phillips stereo) are samples of what was then cutting-edge trick photography, all done before computers.

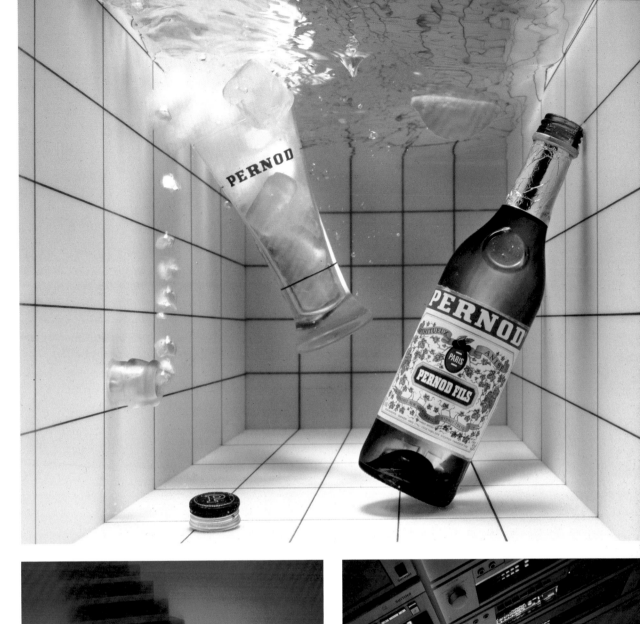

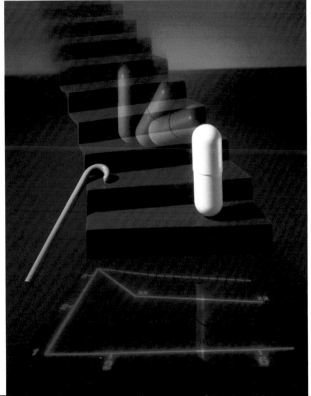

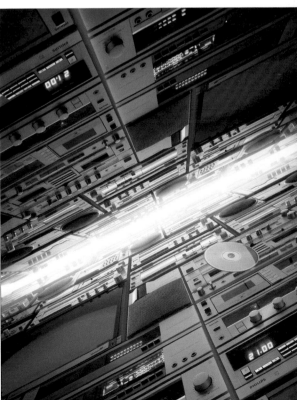

grew more complex, so did the technical challenges. What you will read on the following pages is not only the culmination of thirty years of photography, but also a summation of the last five years of cutting-edge painting with light exploration and discovery.

Painting with light has been around since the beginning of photography. Like many artists who came before me, I did not invent a new technique; I simply rediscovered it (and maybe pushed it a bit further). My hope now is to share with you all of these interesting concepts and techniques. It is amazingly fun, and wildly mind-expanding, to glimpse all that is possible if you only allow yourself to think in terms of what you *envision*, not just what you *see*.

Real-World Clients and Jobs

It seems fitting to address how this particular technique could relate to the real world of clients, deadlines, and photography jobs. In this very competitive world of commercial photography, and to a degree fine-art photography, you are competing with literally hundreds of competent shooters in your area. If you have this one additional technique in your toolbox, you will have an

BELOW AND FACING PAGE—These days, with the use of computers, it is possible to combine several exposures made on location into one homogenous "full" photograph. By mixing traditional scene-capture photography and adding separate painting-with-light images, it is possible to create a much fuller and richer image overall. You'll be doing far more than just "capturing" what you see.

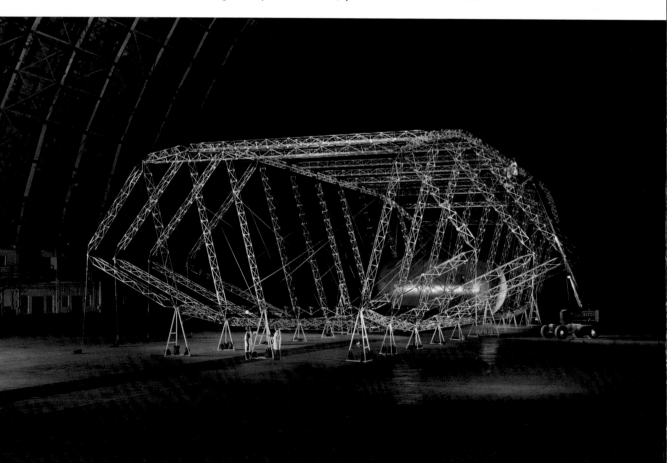

You will bring something to the game that is unique—and much more visually striking . . .

absolute advantage. Not every job will require it, but having a basic understanding of how this technique works will help you start thinking beyond just freezing a moment in time (like other photographers do). If, instead, you begin thinking of layering portions of images on top of each other, you will bring something to the game that is unique—and much more visually striking than a traditional photograph. An added advantage is that you'll gain this benefit without needing to purchase any ultra-fancy equipment or even more lighting equipment than usual. The only resource you will need to add to the job is your own time. That is a flexible commodity and you can determine what it is worth. It is true that creating a painting-with-light photo takes longer than producing a traditional photograph. However, if you can add just a partial effect on top of a traditional image, then you can offer clients something that is still new and unique compared to others.

I have been fortunate in my own industrial photography business, as I have employed this technique repeatedly over many years. Often, it has been called for when a client wanted something better than a regular photo of a scene or when capturing the scene would have required employing several strobe units, many power packs, and a few assistants to lug in all the equipment and set it up. Because of my ability to use the element of time, I was able to do the shoots with a single strobe unit, creating a couple dozen exposures as I lit different areas of the subject. There is no magic bullet, of course; you either spend time and money on obtaining and setting up lots of equipment, or you devote your time and energy to creating multiple painting-with-light exposures and recombining them in postproduction. Either way, you have to put in the work.

Practically speaking, there *are* limitations when using the techniques being shared here. It will be difficult to do even a partial painting-with-light technique on dozens of different subjects in the same job. If you have a project that requires the photography of, say, twenty different objects for a catalog, it will be cumbersome to paint each and every subject to be shot. The time required to recombine these captures in postproduction could also become somewhat overwhelming. Personally, I have discovered that this technique works best when it's applied to something special. Instead of shooting a catalog full of products using the painting-with-light technique, it is far more advantageous to shoot one or two special subjects.

Doing a painting-with-light image is more time-consuming than creating a "regular" image. Therefore, when I employ this technique on paid jobs, it is by necessity offered at a higher price point. I use it sparingly with my commercial assignments, but I go hog wild when it comes to my art photos.

Photography: A Brief History

I'm a professional photographer, not an art history professor, so my understanding of photographic history is straightforward. This brief overview will give you an idea of what has come before and may help you understand how we got to where we are now.

This technique works best when it's applied to something special.

Photography was invented around the year 1837. In the old days, the chemical emulsions that produced an image were relatively insensitive (and the photographer had to add the liquid emulsion to the glass film plate just minutes before the exposure was made). This situation resulted in exposure times that were often as long as several minutes. If you look at small black & white prints of people from eighty years ago, they are inevitably sitting

This tin-type portrait illustrates the limitations of early photographs. Notice the subject's blurry eyes.

Shooting architecture, on the other hand, worked well because the scene did not move over the course of the time required to expose it.

The camera has come a long way since the early days of photography. Originally, significant advances in technology occurred every couple of decades or so. As time progressed, however, the advancements became more and more frequent—to the point where we can now shoot totally film-less with the introduction of digital cameras.

or standing erect and looking very stoic. They are absolutely posing for the camera—and were often held rigidly in place with metal armatures to keep them still during the lengthy exposure times needed to record an image on the glass plates. If you look carefully, you can also see that everybody's eyes are blurry; while it is possible to hold still for about a minute, people can't help but blink. The low sensitivity of the emulsion was also the reason for those "exploding" flash trays; a large flash of light was needed to properly lighten the scene for the camera's exposure.

Much later on, hand-held box cameras were invented—along with pre-made sheet film, like you see in old movies when the newspaper photographers crowd around to snap images of a gangster. Later still, the roll film camera was developed, with a single roll of film on which the photographer could expose a dozen or more images. In the 1950s, the single lens reflex (SLR) camera was developed, allowing the photographers to more easily compose their images.

Today, we have arrived at the era of the digital SLR—and it is this most recent development that has allowed me to pursue my passion to this next level.

Traditional Night Photography

As a young photographer, I enjoyed going out in the evening and capturing long exposures of mundane scenes. Printing the images

FACING PAGE (TOP)—This simple 8-second exposure of the Ferris wheel at the Santa Monica Pier at night is a perfect example of the joy of night shooting. Shooting 20 minutes after sunset allowed some of the horizon's colors to permeate the image, adding yet more depth and character.

FACING PAGE (BOTTOM)—Photographing a freeway from an overpass transforms the pinpoints of car lights into long glowing streaks with each long exposure. By playing with shutter speeds for each exposure, you can make the streaks appear long and wispy or shorter and more distinct. Try to avoid shooting in an area with overhead street lights so the cars' lights stand out against the dark road.

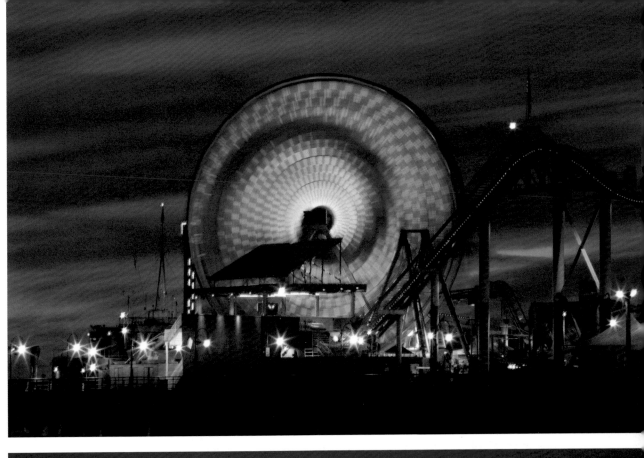

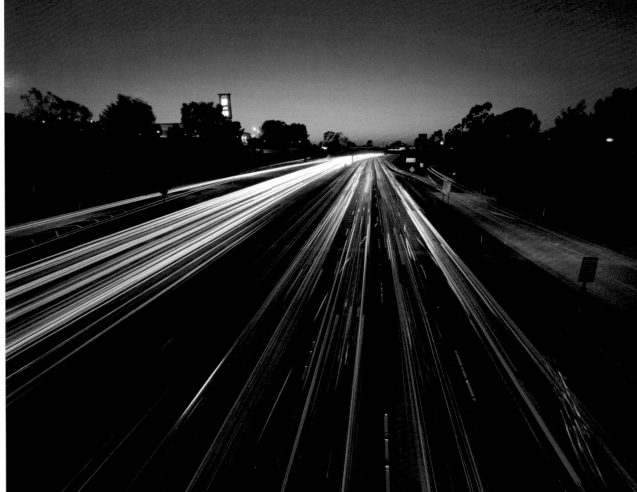

in my crude darkroom revealed something that did not exist to the naked eye; that's the wonder of photography.

There are many styles of night photography to explore, but let's start with the traditional long exposures I just mentioned. With the advent of digital cameras, it is possible to set up a tripod, expose an area of the street or cityscape, and see what you've captured in just a few seconds. That makes it fun and exciting to play with what develops in the viewfinder.

It is also possible to capture long exposures of moving objects in the scene. The classic image that comes to mind is shooting a long exposure of a Ferris wheel at a carnival—or shooting a portion of a cityscape with the taillights of passing cars rendering long red streaks in the scene. And let's not forget long exposures to capture exploding fireworks—fun, fun, fun!

All of this requires only a tripod and a camera with the ability to expose for a few seconds or longer. No pre-planning is needed, and the photographer really does have a sense of exploration. To a degree, you are on the hunt for something new and unusual to capture on your evening's adventure. I think this is the simplest and most freeing form of shooting—just going out and exploring the environment, looking for something to capture.

Painting with Light: Single-Exposure Approaches

Another form of night photography is called painting with light. This is broken down into two basic categories: the single-exposure approach and the multiple-exposure approach (covered in the next section).

One genre of single-exposure painting-with-light night photography involves making a long exposure of the entire scene while moving a hand-held light across the scene to illuminate as much of the area as needed. The point is not to see the light source in the image, only to "paint" light onto the surfaces you intend to light up so they will record in the capture.

This tends to give many single-exposure photographs a sort of, well, *sloppy* look—because light inevitably splashes onto areas you did not intend to paint. As a result, to me this form of light painting often seems to fall short aesthetically. Sure, you can make a long

That makes it fun and exciting to play with what develops in the viewfinder.

FACING PAGE—Here is my nephew Conrad and our new dog Pumpkin Pie. After a few attempts to get the lighting to about the correct brightness and exposure time, it is possible to do one long exposure where I paint on several different surfaces in the same shot. Sometimes you can see the light source floating through the frame. I think that adds character as it is all part of a signature for a one-of-a-kind work of art. This image was shot over about 80 seconds using a small AA flashlight. I turned the flashlight on and off as I walked to different locations in the room to light from various angles. You can even see my face reflecting the red light from the back of Conrad's jacket.

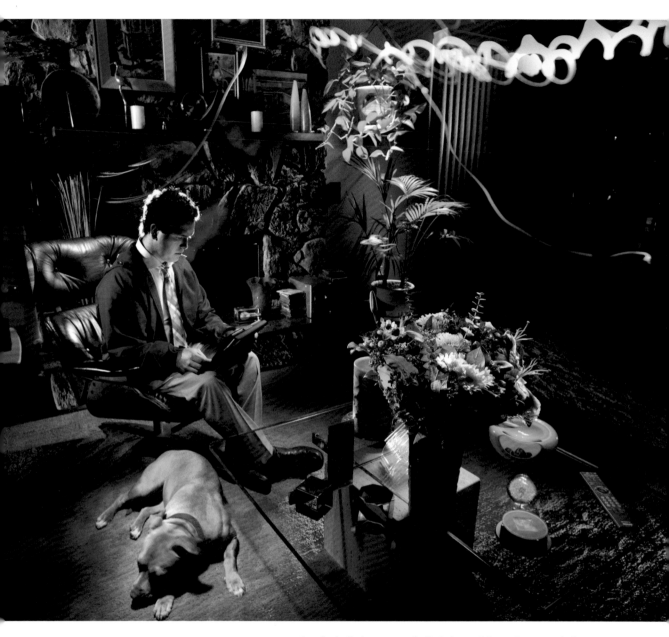

exposure and splash light around, lighting objects here and there, highlighting different portions of the scene seemingly randomly in order to make a painting-with-light photo—and sometimes the effect is actually very pleasing. More often than not, though, it appears random or lucky.

It is difficult to make a controlled exposure of a scene this way because you need to time, inside your head, how many seconds to splash light onto any one area of the photo. Even if you try to

Painting with light is fun and easy. Taking long exposures of a night scene while moving a hand-held light allows the camera to record everything.

create the same photo several times, all the while refining the light painting to get closer and closer to your preconceived vision, the results always seem to have "flaws" where the light wound up in areas it was not intended to go.

Another limitation of this form of light painting is that any ambient light that exists in the scene will be amplified over the course of a minute or so. Eventually, the overall scene will become gray and flat as the ambient light builds up in your exposure. It is hard to paint the entire scene you envisioned without incurring this fogging effect from the ambient light.

When done perfectly, however, this form of light painting is truly beautiful and wonderfully creative. It also has the advantage that it is a bit closer in execution to the idea of an artist literally painting on a canvas; you as the photographer are truly producing a one-of-a-kind work of art in these shots. An added benefit is that when the exposure is completed, so are you. The photo is done completely, so there's no postproduction to deal with.

The effect is pretty neat and very pleasing to the eye.

For a different style of single-exposure, painting-with-light photography, instead illuminating selected portions of the overall scene, you allow the camera to directly see the light source in your hand. As you wave the light about or spin it around on a string, the bright light source records as streaks in the image. You are exposing the moving light and the overall scene as a single picture, so the effect is pretty neat and very pleasing to the eye. Sometimes, however, it is hard to get a correct exposure of the night scene

while simultaneously timing correctly the streaking effect of your moving light source. When you get it right, the night scene is correctly exposed (not too dark; you want to see something more than a pitch-black background) and the frame includes the streaking light effect you desired. The creative possibilities are limitless. (*Note:* It is also possible to break up this kind of shot into several separate captures, each containing a component of your idea. One shot is the overall scene as a traditional long-exposure night picture. Another is exposed to capture the "streaking" of your light.)

Painting with Light: Multiple-Exposure Approach

The style I will address in this book is, in my opinion, closer to the concept of actually "painting with light" than either of the single-exposure techniques described above. To create images in this style, I work in the dark and use a flashlight to paint light onto a small portion of the scene (not the whole scene), lighting up just that section of the photograph. By creating multiple separate exposures, painting a different portion of the scene each time I expose a frame, I'm able to control the lighting to an incredible degree. After the shoot, some or all of these multiple shorter exposures can be recombined into a single amazing photograph.

I work in the dark and use a flashlight to paint light onto a small portion of the scene . . .

Ultimately, what I am trying to do as a photographer is transform a vision or idea I had into a finished image. So very often in life—and, of course, in photography—what we strive to create and what we wind up with are not necessarily the same thing. By utilizing the simple concepts covered in the following chapters and taking the time to divide up your photo into manageable, bite-sized chunks (exposures), you will be able to control each element that goes into making an amazing finished photo. This does not have to be an overly complex processes that requires dozens of exposures to create the look you envision—nor do you have to spend hours in Photoshop recombining the frames you exposed back into a single image. In fact, it is totally possible to create a highly developed painting-with-light image that has as few as two or three separate exposures contributing to the final image. In this

case, the total postproduction time in Photoshop can be just a minute or two.

What I like most about utilizing this particular technique is that it has the ability to draw out the flavor and subtleties of character from your subjects. It is amazing how these straightforward techniques can transform a mundane scene into a powerful and unique work of art.

Additionally, no two photographers using this technique will produce the same shots. When you create your own painting-with-light photos using the ideas in this book, your photos will look different than mine or anyone else's. They will have your own particular style, which is something you will want to foster and refine. Having a signature style helps others recognize your work. This will happen naturally over time if you go out and shoot, learn, refine, and shoot some more.

The simple photograph (facing page) of old hand tools resting against the barn has a wonderful look that was not the result of some filter or click-of-a-button software effect. Instead, it is the quality of the lighting that helps define the character of the scene—and maybe implies much more than just "hand tools." When I created this image, I was striving to communicate to the viewer all the character and inner strength of the farmer who employs these tools daily. When you compare that finished shot of the tools to the "before" shot of the same scene lit with a traditional method of a single light off to the side, the difference is striking.

With all my years of experience as a professional photographer—working with strobes, inside studios, using large-format cameras, coping with clients, deadlines, and all the other varied aspects of professional photography—the process of painting light onto a scene is the most rewarding aspect of photography that I have experienced to date. For me at least, it makes photography more than clicking a button. It results in far more creative potential even than being able to "massage" our photos in postproduction or use several cameras to make a multiple exposures. With this technique, I am able to create something that did not exist before. If you look at some of the before and after images that were shot using my painting-with-light techniques, I think you'll agree that there

These straightforward techniques can transform a mundane scene into a powerful and unique work of art.

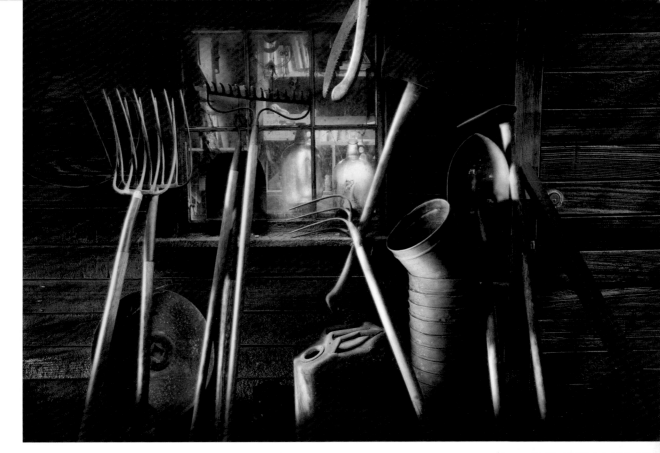

This mundane view (right) of old farm tools resting against the barn looks traditional and boring in my opinion. When I take the same environment and paint light on to specific portions of the scene (above), it is possible to create something that is much more powerful. It's far more than a snapshot of tools against the barn.

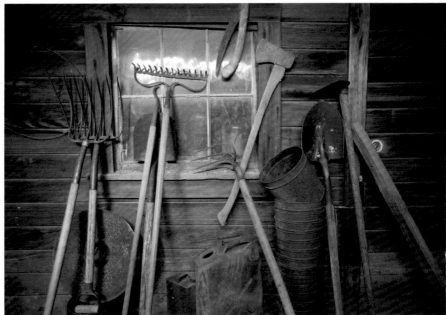

is indeed something happening. The photographic transformation of these scenes came from my own hands, lights, and the decisions I made as a creative photographer.

Create, Don't Copy

It is my hope that, through this book, you will not only learn the mechanics of shooting and recombining images in order to make amazing painting-with-light photographs, but that you will also gain insight into the creative process.

So often during my public presentations and coaching of new photographers, I advise them to think in terms of "concepts." Do not just go out into the environment and photograph neat stuff you happen to see. Instead, take the next step: envision an idea, then try to create what you see in your mind's eye.

For example, most of the photographs in this book were created as part of my series "American Pride and Passion," so there is a strong conceptual thread running through each image. I am trying to capture an entire story in each photograph. It is up to the viewer to observe and explore the narrative buried inside the image. As a photographer, I firmly believe that you will have far more success and fulfillment over time if you, too, think in terms of telling stories with your photographs.

Don't settle for just making great shots of cool stuff at night!

Don't settle for just making great shots of cool stuff at night! Those shots are fun to see, but sometimes they tend to look like yet another "test" of a technique. Likewise, I suggest you avoid overusing filters or software applications—whether it is HDR, high saturation, artificial star bursts or sun flares, blurring, etc. Applied to the image after the shot was created, these all seem (to me, at least) to suffer from that same sort of visual tedium. Everything seems to look the same and there is usually little thought given to the overall concept or idea inside the photo. Simply layering on a software effect is not a style, it is a sales pitch for the software maker. Will anybody else look at such a photo and recognize *your* style? I don't think so. Is that what you want? I don't think so.

As you master the technique of painting with light presented here, you will begin to understand the opportunities available to you when you start thinking in terms of "ideas" and "concepts." This will allow you to make a more powerful statement in your photography.

A last word on this subject: I learned the hard way that this particular technique is so unusual and visually powerful that it can

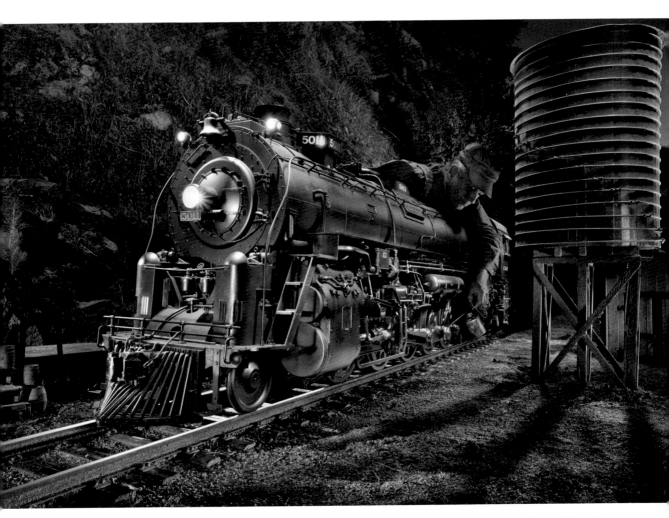

This shot of a small-scale "real" steam locomotive was photographed with the president of the club leaning over the top. It was created by shooting about two-hundred frames and then recombining forty of the best images back into one great photograph. My intent was for the man in the photo to hide in plain sight, so the viewer only discovers him after about a second of looking at the photo. Surprise!

be abused—just like the aforementioned software photo "fixes." Viewers are not used to seeing reality presented in such a clear and yet incomprehensible visual language. They will often ask themselves, "How is this possible?" For me, I am not trying to make something so wild in terms of my lighting that nobody will believe it. I do not want to go overboard and make silly art or crazy lighting solutions that ultimately look like some sort of computer rendering or totally fabricated illustration. Instead, I am trying to enhance reality in order to allow the viewer to share what I saw in the scene or subject—the integrity of a guy who restores an old car or the passion of a man who is determined to be the best he can be at his job. You, too, will find your own voice if you think in terms of ideas.

1. Logistics:
Cameras, Lights, and Other Tools

Cameras: Almost Any Digital Camera Will Work

To paint with light, you do not need a fancy digital camera with hundreds of functions; any camera that has a detachable lens will normally have the features needed to make painting-with-light photographs. In terms of pixel-count, anything above about 8MP is wonderful. The only advantage higher megapixel counts give you is the ability to crop into your finished print a bit and make larger prints for display.

I use a Canon EOS 1Ds Mark III, but I'm a professional and I also use that camera for my professional jobs. If you have the luxury of spending more money on a camera, you will not be disappointed; the quality of today's digital cameras is superb. It is rare that your needs will not be met by your camera's capabilities. I've never had an experience where my Canon could not do what I needed it to do—whether that is critical sharpness, the need to make a ridiculously large print for a show or presentation, or some exotic function or feature needed to make a particularly difficult exposure. Canon came through every time, as will most of the other highly developed dSLRs made by other manufacturers.

There are, however, a few features you really need in a camera for creating your own painting-with-light photos.

Manual Shutter. You need to be able to manually open and close the camera's shutter, shooting an exposure for as long as you want to. If the camera has an attachment for a cable release, that is also very helpful so you do not have to touch the camera physically, thereby avoiding shaking. At a minimum, look for a long timer (about 10 seconds) built into the camera. If the camera

To paint with light, you do not need a fancy digital camera with hundreds of functions . . .

has a manual and/or bulb setting, that is best. It will allow you to lock open the shutter for the amount of time needed for a long exposure.

Manual Focus. You will want to manually focus the scene if possible. Autofocus cameras can miss a shot when you are lighting a section of the photo far away to the side of the frame and the camera doesn't "see" you.

Manual White Balance. You will want to be able to choose the color balance for the shooting session—daylight, tungsten, fluorescent, etc. It is also nice to be able to change from these different white-balance settings when you want to get a color balance that matches the lights you will be using that night or to intensify the after-sunset colors of light at the horizon, for example.

Optical Viewfinder. Lastly, you want to be able to see through the optical viewfinder of the camera. Being able to compose your shots in sometimes dim or darkly lit areas is critical.

Lenses: The Best Focal Length for the Job

What's the best lens for painting with light? A wide angle! Are you surprised that a photographer finally gave that response? Well, it's

This collection of digital cameras is only a sample of the type of equipment you can use. Almost any digital camera will work and be adequate for your light painting. Do not be overly concerned with fancy equipment or high-end cameras. Start making painting-with-light photos with what you have.

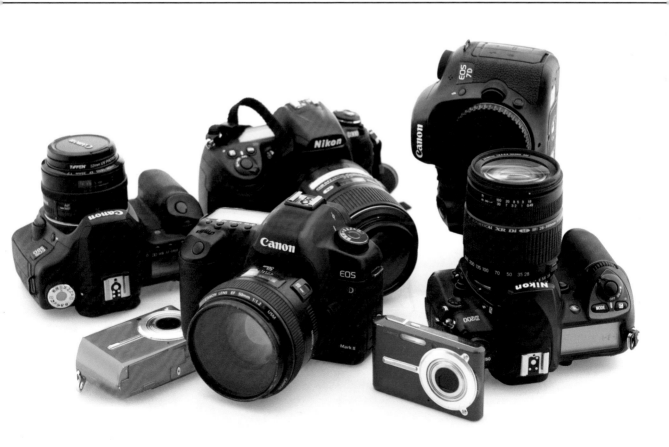

true—and here's why. I think that we humans normally see in a sort of fish-eye perspective. Think about it. When you hold a "normal" lens up to your eye, you see the world relatively "normally"; things are about the same size in the viewfinder as they are to your naked eye. When you shift the camera away and look at the scene with your naked eye, nothing changes in your view of that area; the camera view and your naked-eye view are similar.

However, that does not take into account our *peripheral vision*. Even while you are reading this little book, you are aware of objects and especially movement far off to the right and left sides of your peripheral vision. To me, shooting scenes using a relatively wide-angle or very-wide angle lens closely approximates human vision.

At the same time—and I realize this may sound like a contradiction, but stay with me—I try to downplay the obvious distortion of those wide-angle lenses. I do not want the viewer of my photographs to get a sense that I chose an excessively wide lens. Rather, I want the final photograph to have an overall sense of volume and depth that makes the scene seem "full," with lots of surface areas to observe. This might be a subtle, almost

I think that we humans normally see in a sort of fish-eye perspective.

This composite view of the inside of an observatory was done as research for an upcoming photo session. I was trying to find the optimal angle, with minimal distortion for the whole scene.

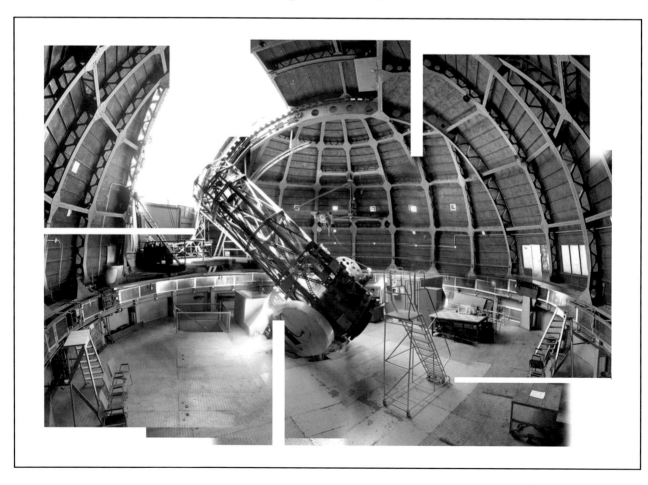

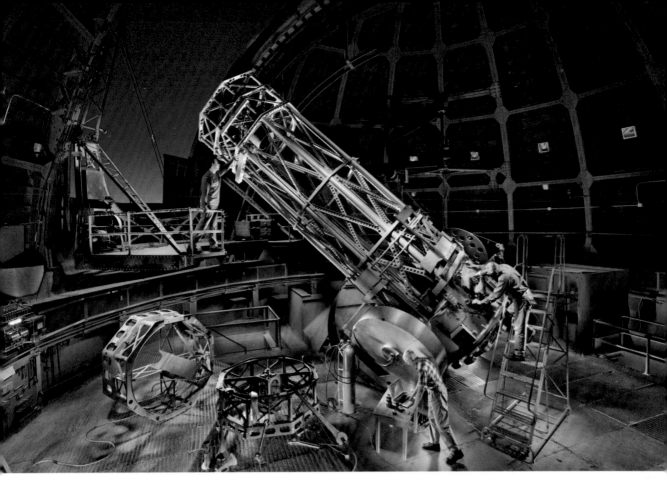

This 60-inch telescope at Mount Wilson was shot with an almost fish-eye lens—yet the view is surprisingly undistorted, as I tried to downplay the wide-lens effect. The message to viewers is the subject matter in the photo, not my lens choice.

subconscious perception by the viewer, but I definitely do not want someone looking at my images to be overly aware that the photographer chose a wide-angle lens.

My advice to you as a fellow creative is to try to remove yourself from the equation as much as possible. That's impossible, of course, given that you will have to make literally hundreds if not thousands of decisions every time you make a new photo. Still, I do not want my finished pictures to be a statement about *me*. At all costs, I do not want the viewer to the finished shot to say to themselves, "Wow—that photographer made a neat lens choice." If that happens, the whole point of the photo is negated; the images are always supposed to be about my subjects and their passions and motivations. Here's a simplistic example: when I was a kid in high school (again, eons ago) and was finally able to afford a wide-angle lens, it was super fun—a shiny new toy! Pretty much every shot I did for the next few weeks was not only wide angle, it was REALLY WIDE ANGLE. I did not just shoot wide,

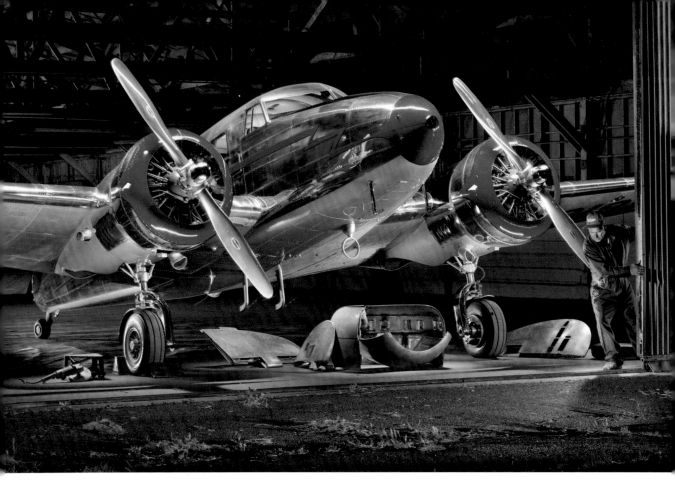

I played up the wide-angle effect by getting close to the ground and looking up at objects, people, buildings, etc. Everything was photographed to accentuate the effect of my new lens. Viewers of my shots were immediately aware of my very first creative choice: a wide-angle lens and forced perspective. Get the idea?

Sometimes, of course, you want to highlight an object that looks great seen from a distance—and I have done that and do it often. But all things being equal, I am going to be the first photographer in history who will actually go on record and advise you to shoot wide. The majority of the shots on my web site and in this series were shot with a very wide-angle lens, but it is not obvious because I downplay the effect of perspective and distortion. If you look closely at some of the shots, though, you will come to realize that you are looking at a great deal of "volume." I am not trying to make a statement about how cool this lens is, I am using the lens as a tool to display the subjects and their environment to the viewer. It is like voyeurism, in that the viewer is less aware of himself or

This view of a beautifully restored Lockheed-12 was shot using a long lens in order to better separate the aircraft from the background. Because of the complexity of lighting this very shiny plane, I wanted to minimize the grief factor by isolating the subject and not relying on lighting alone to divide it from its environment.

the photographer's statement and more aware of the scene and the people.

Lights: Which Lights to Use

There is a wide variety of lights available and appropriate for painting with light, from tiny flashlights powered by AA batteries all the way up to three-million candle-power floodlights.

Smaller Scenes. For smaller scenes, or a shot you want to create of a smaller area, it is possible (and advantageous) to use a tiny AA-powered MagLite® flashlight as your light source. I used one of those for the tractor shot seen below and it was wonderful. If the environment is dark enough, like in a totally dark room or out in the countryside at night (without the glow of nearby city lights), it will work fine on a small scene. All you need the light to

LEFT—These flashlights, from AAA- up to D-cell models, are more than strong enough—if the environment you are shooting in is dark enough. They can also be focused for different lighting effects.

BELOW—This shot, called *Summer Tractor*, was created at night with only a small flashlight and several 10-second exposures.

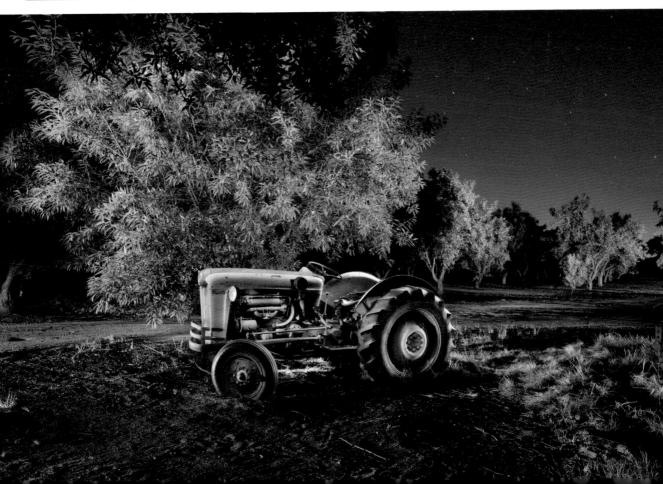

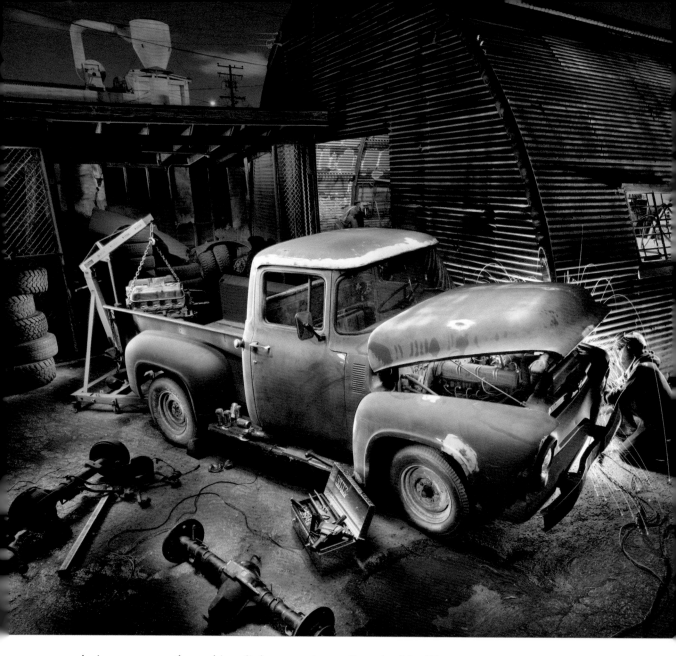

do is overpower the ambient light around you. I used a MagLite because it allowed me to focus the beam down to a small bright spot or dial it out to create a broad beam, covering a larger surface area for painting. For the background of the tractor shots, I used a D-cell MagLite with three batteries inside. It was more than bright enough—even for lighting several trees and dirt roads over about 30 seconds of exposure.

Larger Scenes (and Not-Quite-Dark Environments). Larger scenes require larger light sources. You'll also want larger light

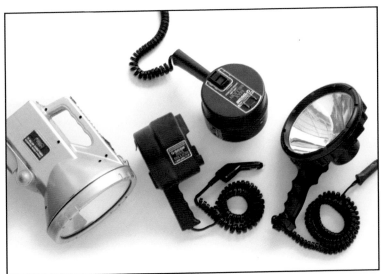

ABOVE—There are dozens of manufacturers to choose from—any large light will work. I suggest using lights with separate batteries so you can "mix and match" lights and batteries as they wear out over the course of an evening's shooting.

LEFT—This 1946 Ford pick-up truck is part of a small business in my town of El Segundo. I arranged to have the truck tucked up against this old Quonset hut for our photo. By arranging objects, buildings, and people, and painting them with light during multiple exposures, it is possible to turn seemingly mundane scenes into beautiful works of art.

sources when you are shooting in an environment that is not totally dark—like my pick-up truck photo (left), which was shot under city lights. For shots like these, I use a hand-held floodlight like the ones used for camping or boating. These can be bought at any hardware store and most department stores. There are lights from dozens of manufactures that will work well; just look around, pick up a light or two, and experiment.

When using larger lights, it's nice to have separate battery packs. If the battery built into a light wears down after twenty minutes, the whole light is dead. If you can just change the battery, it is far more convenient. Sadly, I have found—time and again—that large lights with built-in batteries do not hold up well. They seem to have issues with the wiring, bulb, or switch getting too hot as I use them pretty continuously over the course of a couple hours.

It's too much trouble to be constantly fixing and troubleshooting these combo lights. Also, it is difficult to attach a heavy light with a built-in battery to the top of a painter's pole in order to get the light high above the ground.

If I am in a location that has electrical power (and that is rare), I like to use small theatrical lights. These are generally 100–250W; anything larger is too big to hold and gets too hot to the touch. The lights I'm currently using are called Lowel Pro. They let me focus the beam, making it brighter and more narrow, or dial out to a broad beam that is not as focused. The advantage of using A/C lights is that you don't have to worry about batteries wearing down over time. It's nice to be able to shoot for hours into the evening without worrying about how much "juice" you have left.

Mostly what I am looking for in a light is the ability to "throw" a beam of light. I want to be able to stand on the ground and "shoot" my light up to the top of a building or across the scene to light up the side of a plane or car from farther away. By using what are basically spotlights, I can illuminate surfaces without having to stand right next to them.

Mostly what I am looking for in a light is the ability to "throw" a beam of light.

There are several different lights on the market that will work if you have the luxury of plugging into an outlet. They get hot to the touch but make up for it in the amount of light you can pump onto your subject.

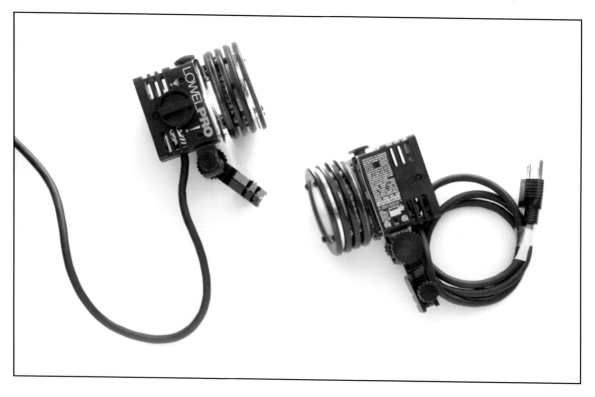

Simple home-made snoots that slip onto the front of my lights prevent stray light from splashing onto the lens most of the time.

It is sometimes also necessary to cover the front of a bright spotlight with a thin sheet of diffusion material. This turns it into more of a wide floodlight that can cover a broad area smoothly. Look for diffusion material that is heat resistant; sometimes these lights get hot.

Snoots: Shielding Light from Splashing Everywhere

You will also want to create simple snoots for your lights. These do not have to be fancy or precise. I started out using black cardboard snoots, which are light and easily replaceable; later on, as my photography got even more ambitious, I created plastic snoots that were glued together. These were designed to slide on and fit snugly over my various light heads so I could add or remove them quickly on location. I also went the extra step and spray-glued black velvet on the inside of the plastic snoots. This cut down any reflections from the very bright light that was reflecting off the inside of the tube. I admit, this was a bit of overkill—but it's in keeping with my obsession to create something wonderful by carefully controlling all aspects of the photographic process.

You want is a device that keeps the bright light from splashing back into the camera lens.

Mostly, though, what you want is a device that keeps the bright light coming from your handheld floodlight from splashing back into the camera lens every time you make a new exposure. This is especially true if the light will be facing even slightly toward

the lens. You want the light from your handheld units to show up on the surface of the object you're painting, not as bright streaks in the exposure. At the end of the process, it's much easier to see each frame clearly when you aren't faced with first removing every hot streak from the light source.

Tripods: Stability Is Key

I strongly discourage shooting night photography and painting-with-light photography using short or flimsy tripods. If you can collapse your tripod down to a few inches long, it's too tiny; you want a tripod that can place your camera at least four feet off the ground. The heavier the tripod, the better—even if it *is* more difficult to drag around. At some point, you will want to hang sandbags (or some sort of heavy weight) from your tripod for increased stability, so a delicate tripod is not good. Under the central column, most newer models have a hook from which you can hang a bucket (filled with something heavy) to weigh down and stabilize the tripod.

Any tripod will do in a pinch, but if somebody happens to kick or bump your smallish tripod, all the photos will be ruined. If you are using a sturdier tripod, the outcomes of an accidental nudge or bump are less catastrophic. I have had this experience several times, and trust me—using a good tripod is cheap insurance for protecting the investment of a night's shooting. I also have a general rule that anybody who is drinking on set is not allowed to stand anywhere near the tripod. It's great for everybody present on location to be

Adding heavy sand bags or a bucket of rocks to your tripod legs while on location is a great insurance against a bump or kick. This is especially needed if you happen to raise the camera far above the ground, as the tall tripod becomes even more susceptible to movement if it is accidentally kicked or bumped. It is nice to have the piece of mind that the extra mass gives to the stability of your setup.

Having a digital cable release allows you to shoot without the help of an assistant to open and close the camera each time you expose the a frame. I have often used these to shoot at night when I am flying solo. They also allow you to open and close the shutter without having to touch the camera, eliminating camera shake.

having a good time, but not at the expense of the final outcome of the shoot.

A Cable Release

There are a variety of cable releases (sometimes called "remote shutter cables") available. These thin, flexible cables plug into your camera and allow you to open the shutter without touching your camera each time you take a picture. When you press the button at the end of the cable release, the shutter is tripped. These cable releases let you lock open the shutter until you release it again. Some of the more advanced models have timers and automatic multiple-exposure delays built into them, so you can (for example) set them to create a 10-second exposure, wait 10 seconds, then shoot another exposure—over and over. That gives you time to paint light onto the scene or your subject. After the allotted 10 seconds expire, you are done with that particular frame and the camera closes again. The device then gives the camera time to process the image you just exposed. When you hear the click of the shutter opening again, you can begin to paint the next frame. It is convenient to have this feature, even if you have helpers at your shoot; it's a *must* if you are working alone on location.

It is convenient to have this feature, even if you have helpers at your shoot . . .

Having a lot of battery power on hand is vital to a long evening of shooting. Whether you are using simple D-cell flashlights, or large hand-held spotlights, make sure you have battery power to spare.

Spare Batteries

What can I say? Batteries are the life blood of the evening's shooting session. Bring plenty of batteries to shoot your whole session—and then some. I have had several stressful and frustrating situations where I was running out of battery power and was not finished light-painting my entire subject. I find that it makes a lot of sense to use the same type of light and battery connections, so you can mix and match batteries and not have them tied to a single light only. All my batteries fit all my lights via a standard D/C cigarette lighter connection (like you find inside cars). This is convenient and gives me complete flexibility. Additionally, I like to label my larger batteries in order of age, newest to oldest. That way I know which battery will have the most "punch" and use it first.

Batteries are the life blood of the evening's shooting session.

Portable DVD Player or Laptop for Screen Display

It is often the case that the process of making a painting-with-light image becomes a sort of group activity. Sometimes, volunteers just want to join me to help or learn some of the tricks. Very often, I have a group of volunteers from the entity being photographed. These can be employees of the business I am shooting, or the friends and family of the guy whose car we are photographing that evening.

It's always nice for all the helpers to see what I get to see when viewing the camera's display as I make each new exposure. By hooking the camera's video output to the input of a portable DVD player, I can make this happen. This prudent investment also allows all those interested to see each new exposure *without* having to stand near the camera or walk around and behind the tripod legs—risking the camera getting knocked out of position. Letting everyone see what's happening (in a risk-free way) is very fulfilling and allows the group to be part of the process as it is happening.

It is also possible to use a laptop for the same purpose, but I like to skip the complexity of using laptops on location. Another option is a new device on the market that clips onto the top of the camera's hot shoe connection. This smallish screen can be rotated forward or sideways so viewers can see the image being captured without having to stand directly behind the camera. So far, these devices are a bit expensive—but the fact that they attach directly to

Simplicity is key when working on location, so I use a DVD player as my portable monitor. It allows me to view each new shot without having to walk around to the back of the camera to see the LCD screen.

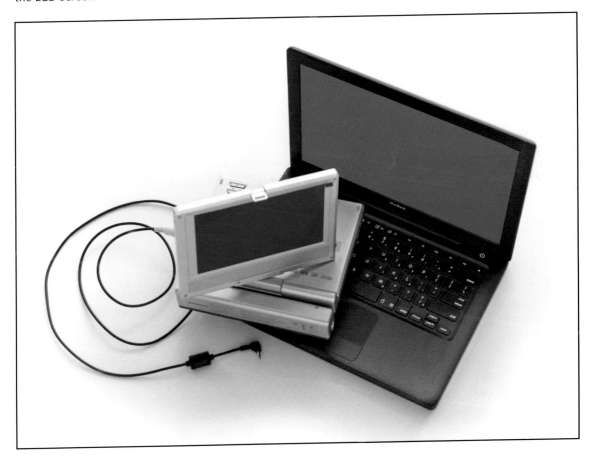

the camera eliminates the risk of snagging a loose or hanging cable and jolting the camera out of position.

Using a separate screen display, like a small DVD player, also helps me judge the overall exposures quickly—without having to run all the way back behind the camera to see what we got for the last shot. After the exposures are dialed in to about the right level, it is easy to judge whether the next group of shots from a different part of the subject are too light or too dark by just looking at even a low-resolution DVD screen display. That's very helpful.

Painter's Poles for Holding Lights

On location, you will often hold the light in your hand and point to the area being painted. It is convenient, easy, and fun to shoot light onto the surface of your subject as you create exposure after exposure. All the while, you'll be changing the angle and direction of your light in order to skim sharp light across an area to show texture, or pour soft light onto the surface to help reveal the three-dimensionality of an object.

Sometimes though, you need to move the light source farther away from your subject. If

Using an extendable painter's pole allows me to place light at the end of a very long reach.

you want to move sideways, it is only a matter of stepping farther away. If, on the other hand, you want to paint an object from above, it is hard to "grow" in height. When you try to paint light onto relatively large objects, it is difficult to stand overhead or on top of them—especially on location. It is not necessary that you light from above an object, of course, but I like having the ability to place my lights wherever I think they will produce the nicest effect. Sometimes, that means that the light will look best if it is dangling 10 feet above a car or truck, for example.

You could bring some sort of scaffolding—or even use a ladder and move it each time you wanted to move your overhead light source—but this gets tiring and does not produce even lighting on your subject. Instead, it tends to create multiple hot spots in each new exposure; you are stuck at the top of the ladder and the light you are holding is trapped with you. The images this produces tend to lack that smooth, even flow of light we're looking for. As a result, they are difficult to use afterwards.

Happily, low-tech solutions are often the best solutions. Absent a natural catwalk or some sort of scaffolding, the easiest way I've found to light from above is to tape my lights to the end of an extendable painter's pole. A pole that can be extended up to about 20 feet is an extremely useful tool and offers a lot of flexibility on location. Using that pole not only allows me to extend my light, it broadens the range of lighting options and solutions that I can apply to any subject. Remember what I said about creating what you envision and not just copying what you see? This simple hardware is, to a degree, part of that process.

The inclusion of a couple home-made extension cords with built-in switches has allowed me to put light on areas that were once out of reach.

I would like to add a separate word of caution regarding safety: As in any situation where there might be overhead power lines or other electrical power sources, *be careful!* You want to keep the extension pole and the light far away from those sources of extreme electrical power. Even if the extension pole is fiberglass or wood, the cable running from your battery to the light at the tip of the pole is still an excellent conductor of juice. Watch out and plan around any potential risks.

Plugs, Switches, and Extension Cords

There's just one hitch when using a long painter's pole: since the lights we've been talking about have only a relatively short electrical cord leading to the battery pack, you can move the light only so far away from the battery (which will be hanging over your shoulder). This is where power cords come in. The inclusion in my kit of several different extension cords with connections for an automobile cigarette lighter and a simple on/off switch built into the line has helped tremendously. I can hold the on/off switch in my hands (while holding the painter's pole) and position the actual light at the end of the pole up to about 20 feet away from me and the battery pack.

You will need to be careful how long you make these extensions . . .

You will need to be careful how long you make these extensions, however; the longer they are, the more drop-off there will be in

the D/C power going from the battery to the light. This is not an issue with A/C lights and extension cords; we all use varying lengths of extension cords around the house without worry of current drop-off. But for D/C extension cords, I have noticed a significant reduction in the brightness of my light if I make an extension cord that is too long. Keep the total length at no more than about 20 feet; otherwise, your light will appear too dim and be relatively useless.

Plan for Comfort

Being comfortable allows for far greater creativity and endurance. On location, I find it invaluable to have several essentials—not only for the volunteers and friends who will help with the evening's shooting session but also for myself. Having these essentials can make all the difference between a taxing, grueling session and one that's both comfortable and rewarding.

I make sure we'll have enough food and drink for everybody present. I like to bring a variety of pre-made sandwiches and chips. For cold drinks, I bring soda and water. If we're shooting in cool or cold weather, I bring hot cocoa, hot apple cider, and hot coffee. After hours of sitting around watching me paint with light in 50-degree temperatures, everybody needs something hot to drink.

I always bring several folding chairs so the folks watching the show have a place to sit; it's hard standing up for hours and hours. In most locations, there are nearby bathroom facilities—but if not, you'll want to be prepared!

Photographically speaking, I pack plenty of gaffer's tape, clamps, sandbags, spare cables and plugs for my lights, extension cords, light stands—and anything else I can think of that might fit. It's always better to have it and not need it than to want it and not have it.

Keep It Simple: A Final Thought on Logistics

I have had several assistants inform me that an electrical generator would produce a lot more power for my handheld lights—or that if I were to use a fancy laptop with the ability to capture the images I am exposing while we shoot I would be able to download them

It's always better to have it and not need it than to want it and not have it.

directly to the hard drive, or that we could even set up several PocketWizards so I could open and close the camera myself. My reaction is usually the same: I like to keep it simple and skip the complex technology when possible. On location, everything is harder. If a gadget breaks, some connection fails, or a computer drops offline, it is difficult to troubleshoot the fault and fix it quickly. It is often the case that I am shooting in crude locations with no access to overhead lights, electricity, water, or even a very clean work space. By keeping the technology to an absolute minimum, I can concentrate on the process of photography and try to make a wonderful picture.

Have you ever had the experience (I bet you have) of carefully packing so many neat photo gadgets into your camera bag that, when you finally arrived at the location, the gear just seemed overwhelming? I've have had that feeling many times—when it came time to unpack a few accessories, it seemed like more trouble than it was worth. I wound up using the basic equipment and skipped all the extra stuff. Remember the golden rule of KISS: Keep It Simple Stupid!

I like to keep it simple and skip the complex technology when possible.

2. Preparing for the Shoot

Scouting the Location in Advance

If you are just shooting for fun, it's wonderfully freeing to just go out shooting night scenes and maybe include light painting on random objects that you come across during your evening's foray. If you really want to stack the deck in your favor, though, it is best to have a plan in mind before you start shooting. Part of that is scouting locations and subjects during the daylight hours, so you can see where you are, identify the best location for your camera, and even determine if there might be any problematic background issues.

It is best to have a plan in mind before you start shooting.

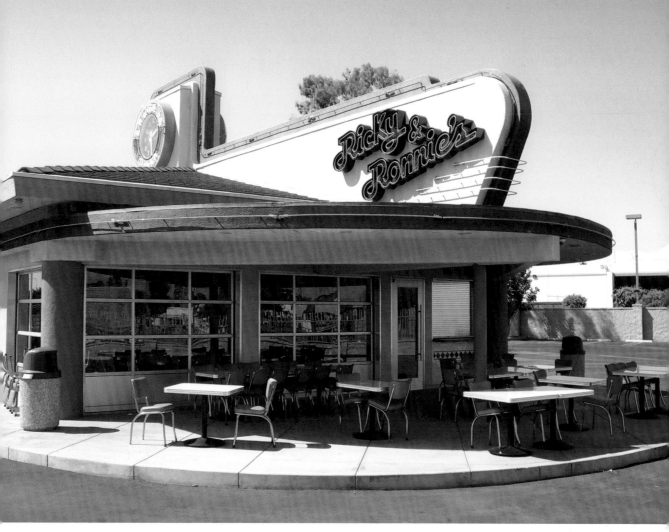

ABOVE AND FACING PAGE—It is helpful to scout locations in advance. In addition to exploring the options and possibilities, you can also determine the best placement for your camera, what existing ambient light sources might be a problem, and which sources might be used in your photo. (Turn to page 48 to see how the above location was used in a final image.)

It is far harder to go out at night looking for subject matter, simply because of the physical logistics of seeing clearly, navigating around obstacles like fences, and accessing hard-to-reach areas. In daylight, these thing are obvious; at night . . . not so much. You will also have the added benefit of seeing the subject in good light so you can fully explore the best shooting angle. I find it extremely helpful to scout my locations early, then take at least a day or so to think about how I will light the subject.

This is all part of having a plan—not just for *what* to shoot but *how* you will shoot it. Think about a possible horizon line in the shot, where to place the camera, and what props to bring (if any). This small amount of energy expended early will help tremendously and will almost always lead to a more successful shot. Think of it in contrast to a typically frenetic fashion shoot. Do you want to

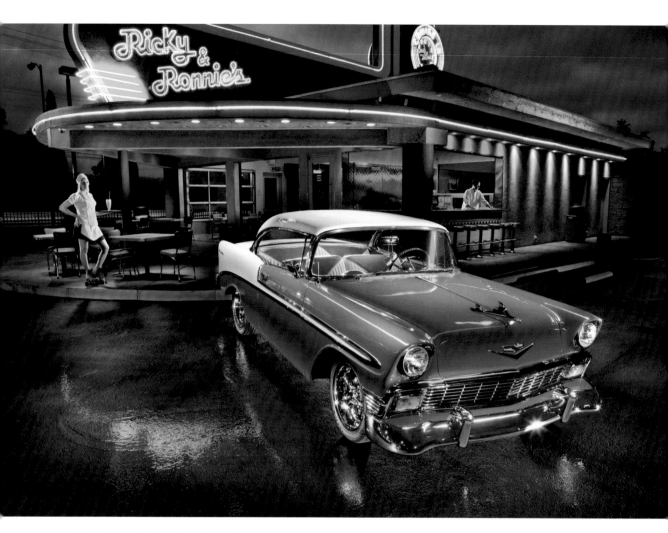

shoot hundreds of random frames, then spend hours looking for the picture that is slightly better than the rest? Or do you want to focus your energy on consciously designing a single wonderful image?

The relatively large volume of a subject like this 1956 Chevy Bel Air makes it a good candidate for painting with light.

Qualities that Make a Good Subject and Scene

I have discovered that the painting-with-light technique lends itself better to certain subjects, where it accentuates the character of the subject or heightens the visual impact of the scene. There are several attributes you can seek to make your final image really sparkle. Think of it as stacking the deck in your favor; you want to include all the elements that will contribute to a successful image.

(And why not go for something beyond *successful?* Why not aim for *spectacular?* When I embark on the creation of a new photograph, I hope to make something that is not just pretty or even really great—I'm attempting to create a spectacular work of art that will inspire and entertain viewers for years to come. I realize it might sound somewhat conceited, but that is my absolute goal. Who wants to make just another "pretty good" photograph? Nobody ever shoots for second place!)

A Subject with Mass. The first thing to look for is a scene or subject with enough mass that you have some surfaces to paint with light. If you look at some of the shots previously shared, you can see that I painted light onto relatively wide and broad surfaces in order to help the viewer see the three-dimensionality of the objects being photographed. When lighting this classic restored vintage 1956 Chevy Bel Air (facing page), I exaggerated the bright highlights on the smooth, rounded surfaces and allowed them to fall off into darker tones of reds and oranges. The overemphasis of these tones really helped reveal the depth of the shape. In every part of the photograph you can see clear highlights and shaded areas where the light falls off the subject as I painted different parts of it with my floodlights. The relatively large volume of a subject like this also allows shadows to form on the ground below it, making the subject more "heroic" and exaggerating the effect of its three-dimensionality. Cars, buildings, planes, and other such subjects look good in painting-with-light images because of their physical presence and large surface areas. Shooting spider webs, thin bicycles, a chainlink fence, or something that is inherently empty space is less fulfilling. There is nothing to really get a hold of with your lighting.

An Interesting Environment. The environment itself, of course, also plays a critical role. If you place a subject in the center of an open field or other empty environment, you end up with a great shot of your subject floating in a void. What made my shots start to sparkle was the inclusion of other surfaces in the environment. It sounds so simple, but it is absolutely critical that the scene is comprised not only of the ground or surface where the object lives. You also need to include back, side, and overhead

> Look for a scene or subject with enough mass that you have some surfaces to paint with light.

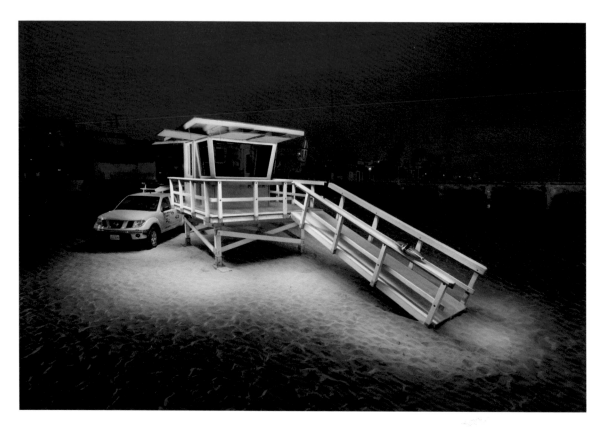

surfaces, painting them with light to build up a whole environment that embraces the subject. When I began doing this, I finally started to see a fuller version of the photo come to life. So instead of just placing a subject on open ground, go the extra step and look for a location under a tree, against a tall wall, or even inside of a structure. Strive to create a photo of the entire environment, not just your subject—sitting pretty, but alone.

Now when I am scouting locations, I try to envision the area to be photographed and mentally tuck myself and my subject deep into the scene by having other surfaces rising up from the background. If it's possible, I include an overhead structure that I can paint with light, too. Earlier on, when my shots had an excessive amount of dark black or dark blue skies in the background, the shots seemed less warm and tended to feel empty and void of character. You can only have so many dark-night, black-sky shots in any collection!

A Dark Environment. Assuming you are shooting with continuous light sources (not flash or strobe; that comes later), the lights you will be holding in your hands are not extremely

It was through trial and error that I learned the benefits of including a full environment. I do not consider this shot a success. It failed because the environment is too empty. There were no vertical surfaces to paint with light and no props or textures to help enrich the overall photo. It's just a lifeguard tower, sand, and dark sky—boring!

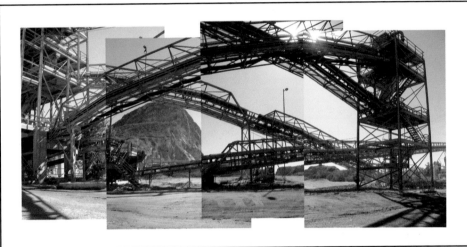

Over time I came to understand the benefits of showing a full environment—and how including the walls, ceilings, or even mottled clouds overhead can add greatly to the overall success of my shots.

Here, the environment was not sufficiently dark; too much of the ambient light recorded on the background.

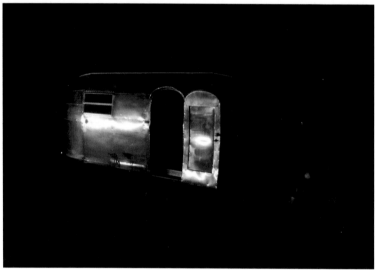

When the environment is truly dark, only the area painted with your light will be exposed. The surrounding parts of the frame will be very dark.

powerful. In an environment with street lights or other meaningful sources of ambient lighting splashing onto the scene, you're going to have a hard time. Even in an environment that seems dark, you'll find that a streetlight a hundred feet away will produce a very bright exposure over the course of 10 seconds.

Essentially, your light sources need to be *far brighter* than any ambient light falling on the scene or subject. I have often decided to not make a particular photo because the location where my chosen subject lived could not be made dark enough. However, I have also covered up several streetlights with cloth or blocked their light with large stands and cardboard. If you're not prepared

A streetlight a hundred feet away will produce a very bright exposure over the course of 10 seconds.

to go to this length, it is easier to choose a location that is as dark as possible. The added benefit of shooting in a very dark location is that you can use smaller handheld flashlights, which appear far more powerful in total darkness. That makes it much easier to shoot and paint.

For More Ambitious Projects, Ask Permission

Here is a little tip that will make your whole night shooting experience simpler and more relaxed: get permission. Often, we photographers seek out unusual (or even slightly restricted) environments in order to create our next shot. I have had the experience—dozens of times—of being interrupted during a shoot by some low-level bureaucrat or person of limited authority who came by to make sure I wasn't trespassing or stealing. It *does* looks pretty interesting when you're doing these painting-with-light photographs, since there are a lot of flashlights shining intermittently over the course of a few hours. This is bound to draw attention if you are in a public space—or even a private space that is visible to passersby.

I have found, however, that when I want to photograph any particular scene or location, the owners are overwhelmingly interested in helping me get access to their property. Having the

> Owners are overwhelmingly interested in helping me get access to their property.

Even seemingly restricted environments can often be photographed if you ask permission. You have nothing to lose and everything to gain. Be sure to repay the access you're granted with a finished print of the photograph you make.

permission and cooperation of the owners is extremely helpful; they can also help with turning out lights or keeping gates opened for your evening's shooting. Also, if anybody happens to come by to see if we're up to no good, I know the names of the owners and can explain that we have their permission.

It's also amazing what a little courtesy will produce. Sometimes I am not only asking permission for access to a site, I also need the active cooperation and support of the owners and users of the property to create the image I have in mind. Even then, whether it's an individual or a giant business, when I ask for permission, the answer is almost always yes. After all, I'm attempting to tell *their* story in my photo. I'm validating what they already know— that their equipment, business, employees, and overall character are special and deserve to be shared. It's karma; you get back what you put out.

For the photographer, the image itself is the reward for investing in this often time-consuming and challenging process— but the other people involved, those who help or grant access, should also be rewarded. After all, this can be a hassle and take up a pretty big chunk of their time. I always offer a free copy or two of the finished images in exchange for permission to photograph on their property. (And don't just promise—you do *absolutely* want to follow through and deliver the photographs as promised.) If I'm dealing with a business, I go the extra step and give them reproduction rights so they can use the image for their own advertising or promotion. It's the least I can do in exchange for the courtesy that has been extended to me and my volunteer assistants.

I insist on having signed and dated property and model releases from everybody involved.

Finally, I insist on having signed and dated property and model releases from everybody involved. It is always a bit uncomfortable asking them to sign that piece of paper—especially as I am coming hat-in-hand, so to speak. I explain that this is a large project and I want to be able to share it with the general public without having to worry about any liability issues. So far nobody has declined to sign; it is customary and not unusual. Also, I try to speak totally from the heart, so I think my true intentions are pretty apparent. I am not trying to trick or scam anybody.

Property Release

1. In exchange for the opportunity for the Property defined below to be included in the photography [and _____ photographic print for personal use only] the undersigned owner or representative of the Property ("Owner"), including the real property, all vegetation, structures, animals, vehicles and other objects located at:_____ (the "Property") grants to _____, together with his and its licensees, assigns, agents, successors, heirs and representatives (jointly "Photographer") the right to photograph, copyright in Photographer's own name or otherwise, and to use and re-use, publish and re-publish photographs of the Property or in which Property may be included, in whole or in part, alone or in combination with other images, text or other matter of any kind, composite or distorted in character or form without restriction, for any purpose whatsoever, including for illustration, trade, marketing, merchandising or advertising of any product or service, for fine art exhibition, for publication, sale or distribution in any manner or media known or hereafter devised, including through electronic media (DVDs, etc.) or over the Internet, through any channels of trade throughout the Universe in perpetuity without restriction or reservation of any kind.

2. Owner further grants to Photographer permission to prepare, publish and use in any manner, captions, stories or other written material reflecting Photographer's opinions, impressions and accounts related to the photography, including the right to use the Property's name, address or location or a fictitious name, address or location, and to describe the Property in incidents related to, based upon or adapted from the photography, including, without limitation, the fictionalization of Property's name or location, in whole or in part, in connection with the rights granted to Photographer hereunder and the exhibition and exploitation of photographs created hereunder.

3. Owner waives any right to inspect or approve any photographs created hereunder or any caption, story, advertising copy or other matter that may be used in conjunction with such photograph(s) and releases and holds Photographer harmless from any liability, claim or expense arising out of any blurring, distortion, alteration, optical illusion, or use in connection with the creation or use of such photograph(s), including without limitation, any claim for invasion of privacy or libel and warrants that s/he is of legal age with authority to make the representations, waivers and warranties herein.

4. This Agreement is the final expression of the parties' intentions with respect hereto and supercedes any other statements, oral or written. It is governed by the laws of the State of California and may only be modified by an instrument in writing signed by the parties. In the event of any dispute between the parties, the prevailing party shall be entitled to recover his, her or its attorneys' fees and costs in addition to any other relief or recovery obtained.

UNDERSTOOD AND AGREED

"Owner"

_____ Dated: _____

_____ Witness:_____
Print Name

Model/Subject Permission Form

1. In exchange for the opportunity to be included in the photography and _____ photographic print for personal use only, the undersigned _____ ("Model/Subject") grants to _____ together with his and its licensees, assigns, agents, successors, heirs and representatives (jointly "Photographer") the right to photograph, copyright in Photographer's own name or otherwise, and to use and re-use, publish and re-publish photographs of Model/Subject or in which Model/Subject may be included, in whole or in part, alone or in combination with other images, text or other matter of any kind, composite or distorted in character or form without restriction, for any purpose whatsoever, including for illustration, trade, marketing, merchandising or advertising of any product or service, for fine art exhibition, for publication, sale or distribution in any manner or media known or hereafter devised, including through electronic media (DVDs, etc.) or over the Internet, through any channels of trade throughout the Universe in perpetuity without restriction or reservation of any kind.

2. Model/Subject further grants to Photographer permission to prepare, publish and use in any manner, captions, stories or other written material reflecting Photographer's opinions, impressions and accounts related to the photography, including the right to portray Model/Subject using Model/Subjects' name or a fictitious name, and to depict Model/Subjects' likenesses, personalities and actions in incidents related to, based upon or adapted from the photography, including, without limitation, the fictionalization of Model/Subjects' actions and speech, in whole or in part, in connection with the rights granted to Photographer hereunder and the exhibition and exploitation of material embodying photographic images created hereunder.

3. Model/Subject waives any right to inspect or approve any photographs created hereunder or any caption, story, advertising copy or other matter that may be used in conjunction with such photograph(s) and releases and holds Photographer harmless from any liability, claim or expense arising out of any blurring, distortion, alteration, optical illusion, or use in connection with the creation or use of any photograph hereunder, including without limitation, any claim for invasion of privacy or libel. Model/Subject warrants that s/he is of legal age with authority to make the representations and warranties herein.

4. This Agreement is the final expression of the parties' intentions with respect hereto and supercedes any other statements, oral or written. It is governed by the laws of the State of California and may only be modified by an instrument in writing signed by the parties. In the event of any dispute between the parties, the prevailing party shall be entitled to recover his, her or its attorneys' fees and costs in addition to any other relief or recovery obtained.

UNDERSTOOD AND AGREED

"Owner"

_____ Dated: _____

_____ Witness:_____
Print Name

3. The Shoot

Set Up in Daylight and Wait

After you have scouted your location and chosen the best angle from which to photograph your subject, it's a good idea to show up at your chosen location with plenty of time to spare—ready for an evening of painting with light. I like to arrive early, so I have enough time to set up the camera and tripod at exactly the best location. Then, I have time to position any props I've decided to use in the photo. With plenty of daylight, I can precisely compose and arrange the scene I will be shooting later. (Of course, if you are only shooting casually and for fun, it's no big deal to arrive late or at night and shoot away.)

I try to be ready to shoot at least two hours before sunset so I have time to contemplate the scene we have created. Composition is a critical factor in designing a successful photograph and being able to clearly see through the viewfinder during daylight hours is extremely helpful. Additionally, I use a lot of volunteers in my photographic sessions, and I never want to be in a position that I need to bark out orders because we are all rushing to be ready as sunset is fast approaching. Since my works are usually collective endeavors, arriving early also lets us all spend time together and consider everyone's input regarding composition and props. All input is welcome; I don't know everything. I like to keep an open mind and consider advice from all sources. Far more times than I can count, a non-professional volunteer has offered a simple insight that really made the shot come alive with just the right attention to a detail or nuance of composition. Of course, while these photographs are very much a collective process, this is not

I try to be ready to shoot at least two hours before sunset . . .

THIS PAGE AND FACING PAGE—During setup on-location for these photos, there is often a lot of activity by my volunteer crews. Moving heavy pieces of equipment can be dangerous, so it is vitally important that everyone be conscious of safety and avoid the tendency to rush. Safety must be everyone's first priority when working on location!

a democracy—I'm the boss! Ultimately somebody has to be in charge, so it might as well be me.

The single overriding factor that I keep in mind is safety. When photographing large or heavy pieces of equipment, forklifts are often used to position the objects. It is never a good idea to have to rush that process by trying to beat a sunset deadline. It would be a tragedy if somebody were hurt (or worse) because of a lapse in attention when large objects were being moved about.

Basic Camera Settings

Noise Reduction. In my experience, the noise that is produced when painting with light is not an issue. We are not taking ultra-long exposures of the stars or the night sky; we're actually making relatively short exposures of dark scenes that we paint light into. When you enable the noise-reduction function on your camera, it almost doubles the amount of time required for your camera to process the shot you just exposed. If you want to make a series of 10-second exposures and you have to wait 20 seconds between each capture, the process will quickly become frustrating. Even without noise reduction, the images you create of a *lighted* portion of your subject will appear pretty normal, not as dark, noise-riddled exposures.

The only time noise is a real issue is when I am making very long exposures of a dim night sky in order to capture streaking stars in the sky—or when I'm exposing for 20 or 30 seconds to capture a distant tree being painted with light. During those exposures specifically, it is advantageous to have my noise reduction turned off so I do not have to wait long between those excessive exposures.

White Balance. Most digital cameras have the ability to balance the color in your captures to the light source you are shooting in. Usually, it is perfectly fine to set your camera to the tungsten

It almost doubles the amount of time required for your camera to process the shot . . .

This is what a typical scene will look like if you light with the correct color balance. In this case, I was using tungsten lights and had my camera set to tungsten color balance.

If I had my camera set to daylight color balance when lighting with a tungsten light source, the scene would appear overly yellow and too warm.

If I had my camera set to daylight color balance when lighting the scene with a fluorescent light source, the overall effect might appear too greenish (depending on the particular color of the fluorescent light I was painting with).

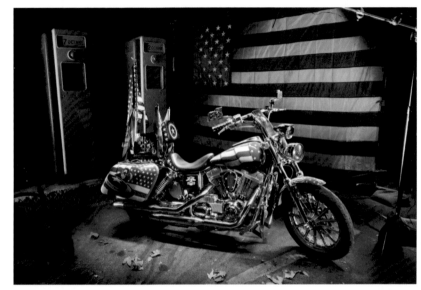

Here's what you might see if you had a tungsten setting dialed into your camera but were using a very cool light source, such as a strobe—which is quite blue compared to tungsten lighting.

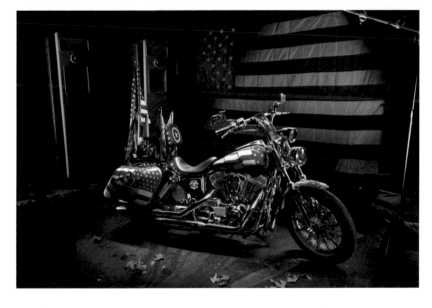

white-balance setting; it will match most of the handheld flashlights you'll be using. It is also possible that the daylight setting will fit, depending on the kind of lights you are using. The easiest way to see what might be a good match is to do a couple test exposures on location. Try several white-balance settings with the light you will be using and see which one gives you a cleaner color balance (the most neutral "white") by checking your camera's LCD screen after each capture. If you are using a strobe or flash to paint with light, then set your camera's color balance to the strobe setting. If this all seems like too much trouble, just set your camera to the automatic white-balance setting and let the camera choose the setting that fits best for any particular light source you are using. Generally, the color balance will be pretty good—not perfect, but close enough. You can critically color balance each exposure as you stack them into the final image during postproduction.

File Format. It is definitely best to use the RAW setting whenever possible. This will give you the greatest flexibility and latitude when it comes to manipulating your images afterwards. I always shoot RAW—and because of that, I am not overly concerned with getting the exact color balance or an extremely precise exposure while on location. I know that I can go back to the file and tweak it until it's just right. (Actually, until recently, I was making the mistake of shooting RAW then exporting the images as large JPEGs. My Photoshop tutor—yes, even I need help here and there; nobody knows everything—slapped my hand for doing such a dumb thing. Basically I was throwing away all the information imbedded in the original files by exporting them as JPEGs instead of PSDs.)

There are a few disadvantages to shooting in the RAW format. For one thing, the files are substantially larger and you will not be able to shoot as many on any given CompactFlash card. Also, it is a bit trickier to open up a RAW file; you will need software like Adobe Camera Raw that is designed to read RAW files. When I used to shoot high-quality JPEGs, it was easy to just drag my files into any program—and they would open up the first time. For that reason, if you are an amateur and just playing around with painting with light, or maybe just getting started, I think shooting

> It is definitely best to use the RAW setting whenever possible.

high-quality JPEGs is fine. It expedites the process of getting your images from the camera to the computer program you will be working with. Later on, as you progress in photography and Photoshop, you can transition to shooting RAW.

Another issue to keep in mind when shooting RAW is that, because the files are so much bigger, when you start adding several images on top of each other in your Photoshop file, the total size of the image you will be working on will get quite excessive. As a professional, I have a ridiculously large computer with gobs of RAM and hard drive space so I can deal with these enormous files. If you don't have sufficient computing power, these big files will bog down your system. With a couple dozen large images stacked on top of each other as you make your final photograph, the computer will take longer and longer to process each new command. It will also have a tendency to crash if the files get too big for your system. This factor could be another reason for choosing to shoot JPEGs instead of RAW files for your personal work.

ISO Setting. I'm often asked which ISO is best or which one I like to use. Honestly, it really doesn't matter too much. I like to shoot around ISO 200. If I am using a very powerful floodlight and the subject is too bright even during a short 3-second exposure, I'll cut the ISO down to 100. If I am using my floodlights and exposing for 8 seconds and the subject is still dark, I'll increase the ISO—up to 600 if I have to. The only risk of using a very high ISO is that you will start to see noise in the exposures, especially with exposures longer than 16 seconds or more. I am never bothered by that; it is a part of the photographic process and does not kill a photo *per se*.

Aperture Setting. What's the best aperture? This is a classic question that all professional photographers love to tease amateurs about, answering (to the amateur's surprise), "There is no 'best' aperture." For this technique, I disagree. When it comes to painting with light, I like to shoot at about f/16. If I shot wider, the whole scene might not be in focus from the foreground to the far background. If I went too far and shot at f/20 or f/22 it would take a lot of light to actually illuminate the scene. Additionally, if

The total size of the image you will be working on will get quite excessive.

you shoot with a very high aperture setting (f/20 or f/22), you may even *lose* critical focus. It sounds counterintuitive, but while the overall scene may have greater depth of field at a smaller aperture setting, the overall shot can lose that critical razor-sharpness that exists at the lens's optimal aperture, which is normally a mid-range setting like f/11 or f/16.

Focusing. Once the photo session begins, you cannot change the focus. I actually use a piece of gaffer's tape to immobilize the focusing and zoom rings on the lens so it cannot change or shift over the next two or three hours of our shooting session. Even if the setting did not shift on its own, it is possible to accidentally rub against or touch the focusing ring, just because we are so used to constantly fiddling with it. A piece of tape is cheap insurance.

When setting up in the daylight hours, it is easy to see what is in focus and what is slightly blurry, of course. My general rule is to focus on the primary subject matter. I might pull the focus a bit closer to me to include some of the foreground props, making sure they are also sharp. It is best to literally rack the focus back and

Once the photo session begins, you cannot change the focus.

Attaching a simple piece of gaffer's tape to the lens locks down the zoom and focusing rings to ensure that, during the evening's shooting, the whole scene will remain focused and at the same zoom setting.

Adjust your lens to the manual focus setting. If you forget, it's possible the camera won't accurately focus each of your exposures. It may even create several frames that are far out of focus—it has happened to me.

fourth several times to get a feel for where you want to critically place the focus in the final sequence of captures.

Also, make sure to turn off your camera's autofocus feature; you need to manually focus on your subject. If the camera is determining the focus for each shot it might miss the correct setting if you are standing to the side and painting light on an obscure section of the photo that the focusing sensor doesn't pick up. Or the focus might change from the foreground to the background as you move about the scene painting with your lights. The change of focus is not so critical in and of itself, but the *actual size of objects* also changes slightly in the frame as the camera chooses where to place the focus, close or far. Manually focus one time—and set it permanently.

Begin Shooting

Don't Move the Tripod or Camera After You Start. Up to the point when you are starting to shoot your first frames, just after sunset, feel free to continue to tweak and play with the camera and props, moving them about to get exactly what you want. Once you shoot your first frames, it is too late to move anything in

Once you shoot your first frames, it is too late to move anything . . .

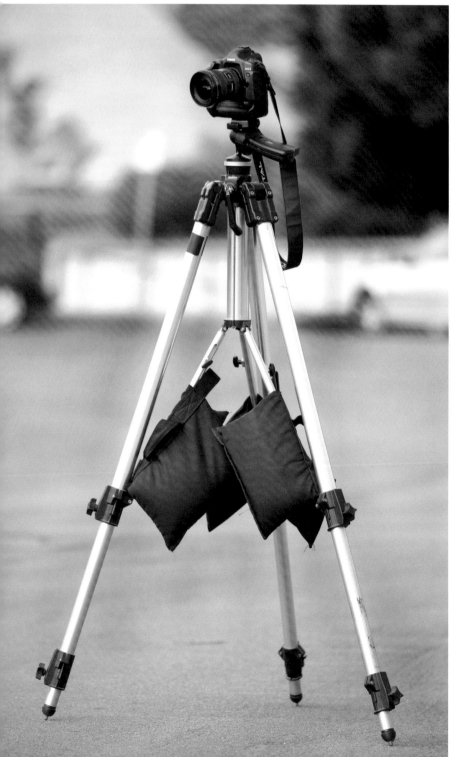

Several sandbags hanging over the legs of my tripod add a great deal of stability to the whole tripod and camera setup. Even if the tripod is accidentally kicked or bumped, the heavy weights will help ensure that the whole rig will (most likely) remain in exactly the same location and not get nudged out of alignment.

the scene. Remember: after you are completely finished with the evening's session you will be stacking many of these photos on top of each other. Therefore, if something in the frame moves between exposures, the light you painted onto its right side may not line up with the light you painted onto its left side. The worst mistake is if the camera gets moved or somebody kicks the tripod during the shooting process. Nothing from before the kicking incident will fit with anything exposed after the tripod got moved! I recommend placing sandbags on your tripod legs, or using a plastic bucket filled with rocks (or something else heavy) to securely weigh down the tripod.

Shoot the Whole Scene. After I have set up my tripod, I create several exposures of the entire scene (where everything is visible

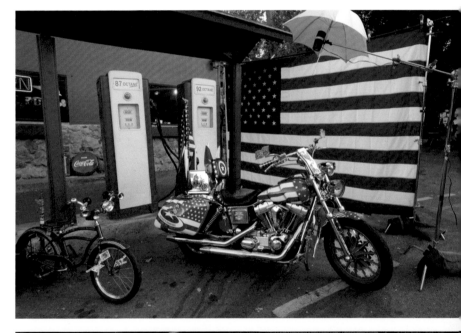

The worst mistake is if the camera gets moved during the shooting process.

After setting up my tripod, I shoot several exposures of the entire scene.

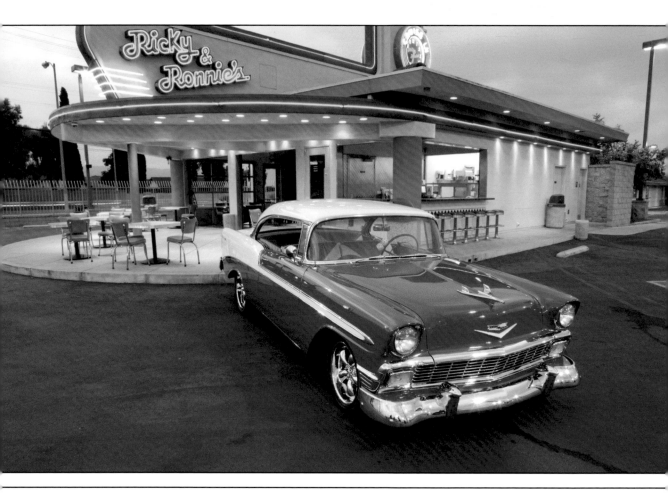

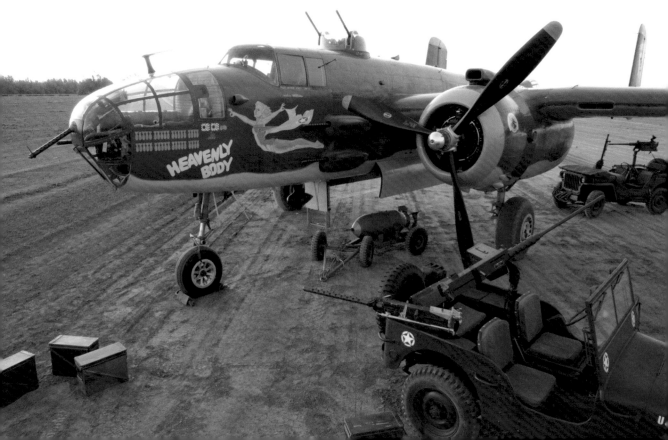

It is always nice to include

a piece of the horizon

in the distance.

in the frame) before it is totally dark. For these shots, you may want to change the camera's white-balance setting to open shade, so everything does not go too bluish. After the shoot, when I am recombining all the pieces that go into making a final photograph, these images give me something to refer back to—a road map of all the components.

This overall scene capture is also helpful as an insurance policy. If (God forbid!) I actually forget to paint light onto any particular portion of the scene, I can go back to this full and complete shot of the scene and pull out a portion of the scene to plug into the painted-with-light photo I am making. This works well in a pinch—especially if a small section or odd detail from the shadow side of an object or prop was overlooked during the location shooting process.

Capture the Sunset. When working outdoors, it is always nice to include a piece of the horizon in the distance. For me, this inclusion of depth and space makes the final image richer and even more compelling. If you can compose the shot to include the area of the horizon that will include the sunset (or anywhere near the sunset sky), you can capture those beautiful colors that still linger low on the horizon long after sunset.

As noted above, I'm in the habit of shooting overall frames of the scene just after sunset—and I continue to do a shot or two every ten minutes until I have a full, rich pallet of different horizon light that fades up to black at the top of the frame. Even long after sunset, I will shoot a 10-second exposure for just that portion of the photo. It's amazing how beautiful the horizon can be with a long exposure, even twenty minutes after the sun actually sets.

During this process, try adjusting your white-balance settings just to see what might happen. Shooting the horizon using a fluorescent, strobe, or even tungsten white-balance setting will give you some wild variations. Often, the colors are so far off that the frame is unusable, but sometimes these unusual color-balance settings will nicely exaggerate the reds, golds, or blues of the low light clinging to the distant horizon and give you something unexpected to work with later on. Think of it as a free gift; you just have to be open enough to look for it.

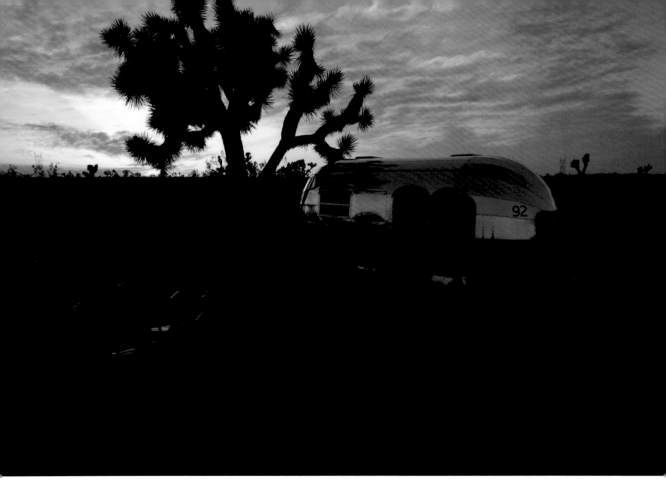

After shooting a few of these images, remember to change the camera's color setting back to tungsten so it is appropriate for your handheld flashlights. Remember to bracket, too; shooting digital images is free—so shoot away.

Exposure

Charts, Graphs, Exposure Tables, and Formulas? Skip It! I don't think I've ever seen a how-to book that didn't include some sort of mathematical formula for calculating some critical value—or one that was not chock full of graphs and exposure tables. For me, and I assume I am reasonably normal (although my wife refutes it), this seems somewhat overwhelming—especially considering the challenge of determining these critical values on location or under less-than-ideal circumstances. Things are always harder on location, even if that location is just your backyard.

For this reason, I prefer the good old-fashioned method of relying on common sense and experience. Because I know my

Things are always harder on location, even if that location is just your backyard.

THIS PAGE AND FACING PAGE—These frames of the distant horizon were exposed long after the sun actually set. Including a distant sunset horizon is a useful element to have as part of your final composition and can add greatly to your finished photo.

While the information displayed in the camera's charts and graphs is helpful, I find it easier just to look at the test exposures and determine if the shot needs to be lighter or darker. On location everything is harder, so use your common sense and skip the fancy calculations.

camera, my display, and my computer monitor, for example, I know that I need to capture images that look slightly light on my camera in order for them to look "normal" on my home computer. That bit of experience with my own system is critical. If you have even a little bit of practice working on images on your own system, then you probably have a good feeling for what is appropriate for your setup.

When trying to determine the best exposure for any given painting-with-light situation, I suggest you simply snap a quick exposure of around 5 seconds. Then look at the back of the digital camera to see if it is about right. If the image is underexposed, you can increase the ISO setting, open the aperture, or choose a longer shutter speed. It's also possible to get a brighter flashlight. If, on the other hand, the test image is too bright, you can reduce the time you paint with light, close down the aperture, decrease the ISO setting, or even pull the light you are using farther away so it is less bright on the subject.

What's "Right" Is Subjective. Don't be overly concerned about getting absolutely, critically correct exposures. Photography

You probably have a good feeling for what is appropriate for your setup.

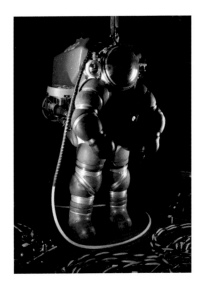
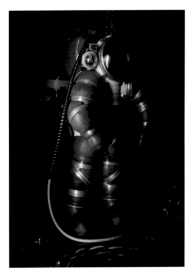

These three examples demonstrate an overall too-bright exposure on the left, a normal exposure in the center, and a too-dark exposure on the right. Get a feel for your camera and the subject matter, then use common sense to make the process easier and more fun.

is subjective and the way you light a subject will be different from the way I or anybody else might do it. Make exposures that look right to you. Sometimes my "correct" exposure is a bit bright if I want the subject sitting center stage to seem to glow. Objects in the background, or portions of the overall scene that I do not want to emphasize, will be lit more delicately so they appear less important, with less detail and less contrast. Not everything in the frame is equally important, so it is appropriate that some shots be darker than others. Basically, your main subject and anything really important to the shot will need to be lit and exposed normally so you can work with it afterwards in the recombination process. If a frame is too dark because you did a bad job of exposure, it's hard to fix that in the computer. It is far better to aim for the middle range of good, normal exposures.

Making Basic Exposures. As a general rule, I like to keep the individual exposures of any particular areas of the scene to around 6 seconds. During the exposure, you will be painting light onto only a small portion of a subject. However, if you don't have enough time to smoothly and evenly paint light onto the whole section of a fender, for example, then that exposure will look choppy and sloppy. You want the exposure setting to give you enough time to paint your light evenly over the entire section you chose to paint in that frame. When you want to expose a frame that is the entire side of a car, you can use longer exposures of 10 to 16 seconds.

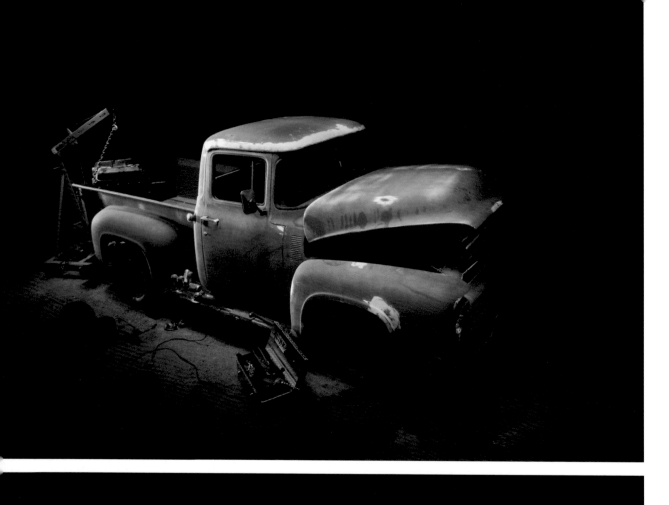

THIS PAGE AND FACING PAGE—These exposures are good examples of light painting. Notice how a portion of each subject is evenly lit while the backgrounds are dark.

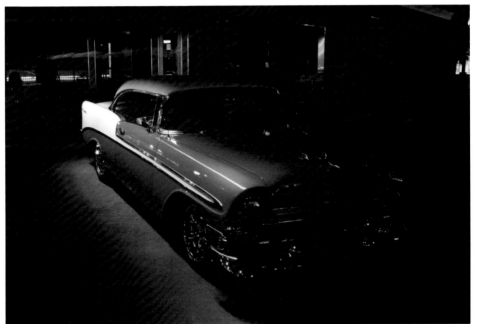

You want to be able to brush the light back and fourth two, three, or four times during the exposure time in order to avoid creating bright areas or hot spots. Just like a painter air-brushing a surface, you'll find that several light coats are much better than one thick coat (isn't this totally cool?).

You want the painted-light portion to be normally exposed while the remaining portion of the frame (the part you did not paint with light) remains very dark in relation to the painted area. If there is too much ambient light in the overall frame, then the area you painted will not separate visually from the rest of the frame or the background. It is absolutely critical that your subject stand out as a brighter area on top of the dark environment around it. I have learned the hard way that it is not desirable—or even feasible—to go back to my individual exposures and "cut out" the objects I painted. If they do not separate themselves because of the lighting, cutting them out and pasting them into a finished photo will look totally fake.

Shutter Operation

Because you'll need to create so many individual images, it's extremely helpful to have a friend or assistant available who can open and close the camera on demand. I literally say "Open!" and the camera assistant will open the camera. After I have painted that frame, I shout "Close!" and my assistant will close the shutter via a cable release. (I have to shout because I am sometimes far away or it is a noisy environment.) This approach lets me work much more quickly; I can simply move on to the next area to be exposed while the previous shot is processing.

Of course, another option (and I have done it many times) is to set the camera on manual and lock the shutter open. I then expose the individual part of the scene and run back to close the shutter, minimizing noise build-up in the exposure. This is a bit tiring, but it's totally doable if the scene is not too large. Allow some extra time if you're shooting this way. A few seconds for each trip to and from the camera may not sound like much—but when you multiply it by hundreds of exposures over the course of an evening, it really adds up.

FACING PAGE—These are bad examples of light painting; the subjects are not exposed well in relation to the background. The shots were done before it was dark enough and the ambient light is too prominent in the overall exposure.

It's extremely helpful to have a friend or assistant available . . .

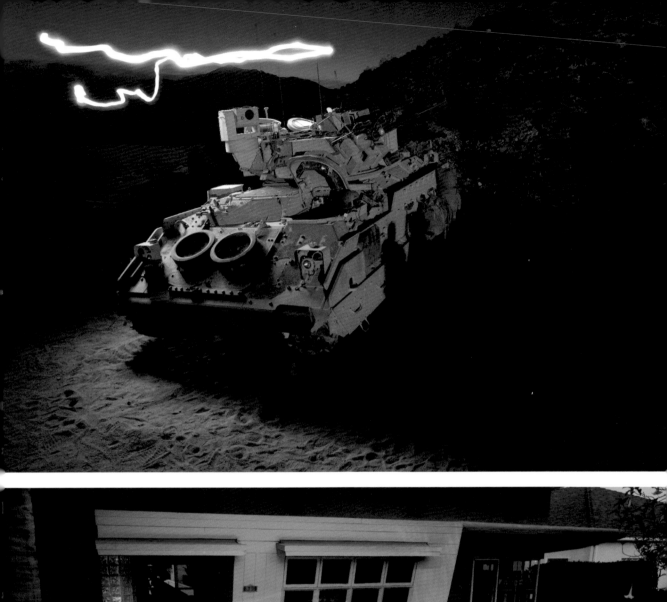

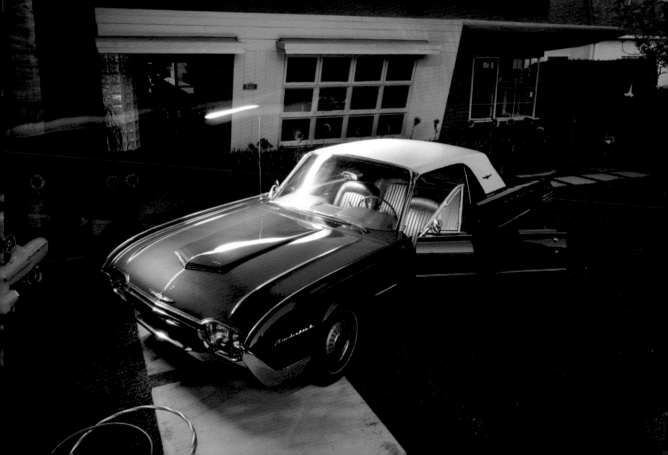

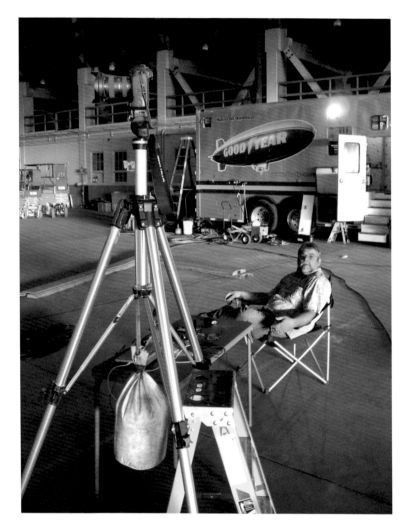

Here, we were shooting the Goodyear airship on location inside the very large hangars at Tustin, CA. My friend Brian is all set to operate the camera on my commands. When this shot was taken, we were just waiting for darkness to get started.

Another option is to use handheld slave units to open the shutter remotely. This saves you having to run back to the camera after each shot—but for me, it's just too many gadgets to have to deal with. After all, my hands are generally full of lights, batteries, and extension poles. You want to keep your head in the game of *lighting your subject,* not get distracted with too many gadgets.

You want to keep your head in the game of lighting your subject . . .

Lighting the Subject and Environment

Here is the meat of the process of painting with light. What you are doing is capturing the scene you chose (or created) over the course of several exposures (or hundreds of exposures) during the shooting process. While the experience is wonderfully fun and, in my opinion, kind of magical, it all needs to start with a plan.

Have a Lighting Plan. "The quality of the lighting!" My old photography instructor Charlie Potts, from Art Center College of Design in Pasadena, used to speak this phrase to us photo students. In those days, I was too young and arrogant to credit how accurate his words were. Now, after thirty years shooting as a professional, I can assure you that he was right: the secret to great photos is the quality of the lighting. You can transform an old, dirty boot into a photographic masterpiece if you light it well.

With that in mind, it's important to have a plan for what you're going to do on location when lighting your subject and scene. I use the lighting in the finished photo as a storytelling element; it's essentially an additional prop that helps me communicate what

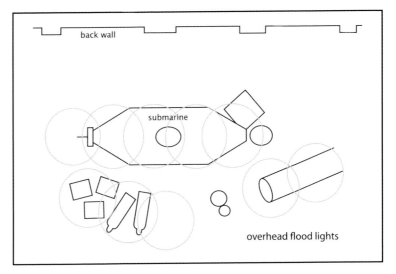

These diagrams reveal how the submarine image was lit. For this shot, and most of my photographs, I used a combination of skim lights and floodlights. Here, the skim lights directed light across the submarine, props on the ground, and the back walls of the factory. Later on, I went back and made exposures of the same objects, this time lighting them from above with broad, smooth floodlights for a soft, even effect. I even added light from behind and below the submarine to give it more "stage presence" and add drama to the overall scene.

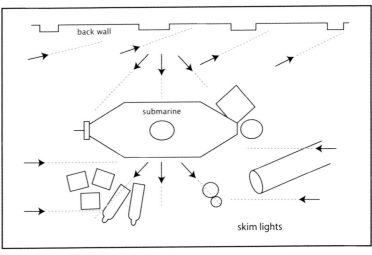

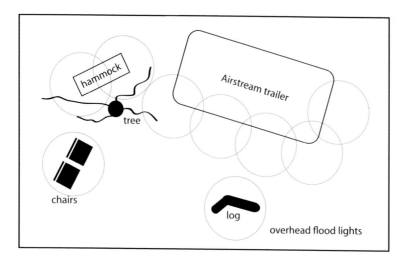

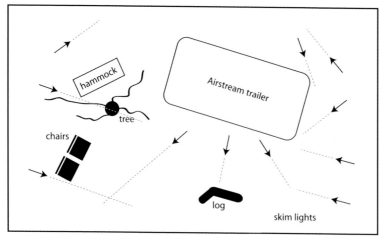

These diagrams for the placement of my lights reveal how I am basically using two different light sources repeatedly. I skim light from the side to light the environment and the objects in the photo. Later on I will go back and light the objects in the shot with a floodlight from above and individually expose shots of the chairs, trailer, and objects on the ground.

is happening in the photo. I literally think about the lighting for days—if not weeks or even a year (sometimes these shots take a long, long time to come to fruition)—before the shoot.

Being able to think about how you will light a scene is critical. Yes, you *can* just make a bunch of exposures, lighting from top, bottom, side, back, etc.—but if you have in mind what you are trying to do with the quality of lighting, it will be easier and more fun. Keep in mind that when you're working on location, things tend to get a bit confusing. After you have shot a couple dozen frames, you might ask yourself, "Is that all? Are we done?" It is only after you return home that you realize you forgot to expose the inside of the engine block, or forgot to light the top of the old car, or skipped that one exposure that would have been *really* great to have . . . if only you'd thought of it on location.

Being able to think about how you will light a scene is critical.

Work on Small Sections. For the best results, you need to shoot a lot of images, isolating small areas of the scene/subject in each frame. If you shoot only two or three big exposures, any mistakes you make in a particular area of the subject will be tied into the whole frame. That means it cannot be removed easily. If you accidentally hold the light too long on the fender, that whole shot is ruined because of the fender's overexposure. By slicing up the overall image into manageable, bite-sized pieces, you can take control of the whole scene. Sure, it's more work to do a lot of separate exposures, but painting each section individually lets you pick and choose the individual frames that work best for each part of the subject.

Try Some Variations. Each time you shoot a piece of the subject—the left fender of an old car, for example—go ahead and make that exposure a few times so you have one frame that was lit slightly from the side, one exposure where the light was directly overhead, and one exposure where the light was skimming the fender. That way, when it comes time to combine all the different shots you did on location, you will have several shots of that specific fender to choose from. You might only use one of the shots, but it's nice to have choices.

Suggesting that you try some variations does not, however, mean that you should be randomly splashing light onto the subject. For these images to make sense, the light has to have a logical source. There must be a direction from which the light on the subject primarily originates. If you look carefully at many of my shots, you will see that there appears to be one overpowering source of light coming from above, either to the left or right of the frame. If you think of this in general photographic lighting terms, this is the main light. While the "one overpowering source" is actually comprised of numerous separate exposures, its consistent overall placement makes it look as though I might have placed a giant softbox just out of frame. This helps the viewer accept the reality of the overall scene. If your lighting is too crazy, you run the risk of having the shot look fake or overly computer-rendered. As a result, viewers will dismiss it as being something other than a photograph.

You might only use one of the shots, but it's nice to have choices.

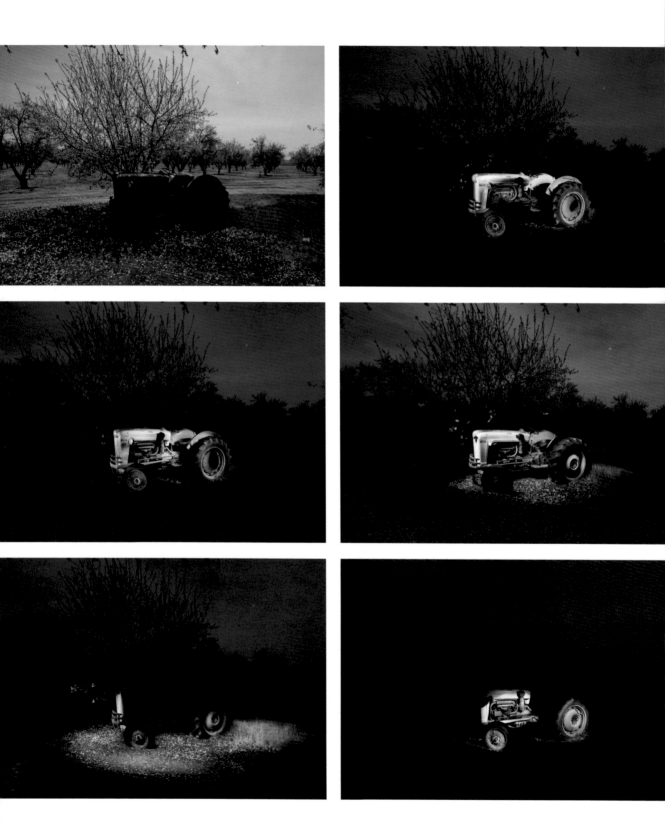

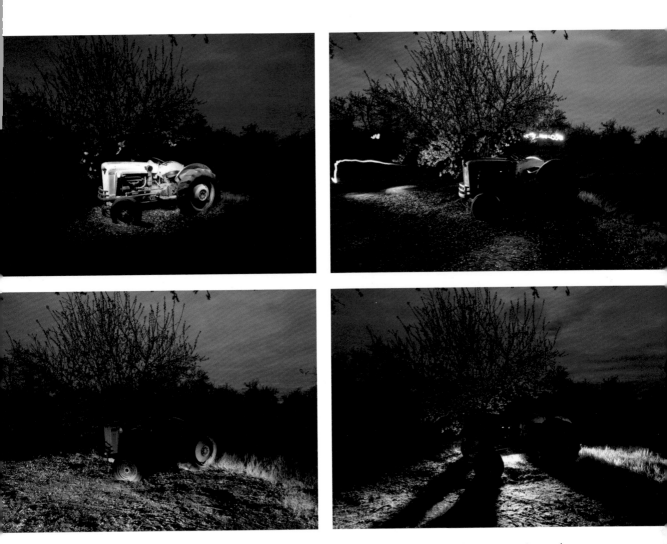

ABOVE AND FACING PAGE—Exposing several variations of each portion of the scene gives you options when you add the images back together. You can mix and match shots made on location in order to get that perfect look.

I am careful to get as many variations of the basic lighting as I can within the time allowed, but more importantly I am doing variations of the lighting I wanted *most*—the most important light for the subject. In order to know what's important, however, you have to go into the shoot with a lighting plan.

I might light the same object from different angles in order to get slightly different looks. I can use one or more of these images when building the final photo in Photoshop.

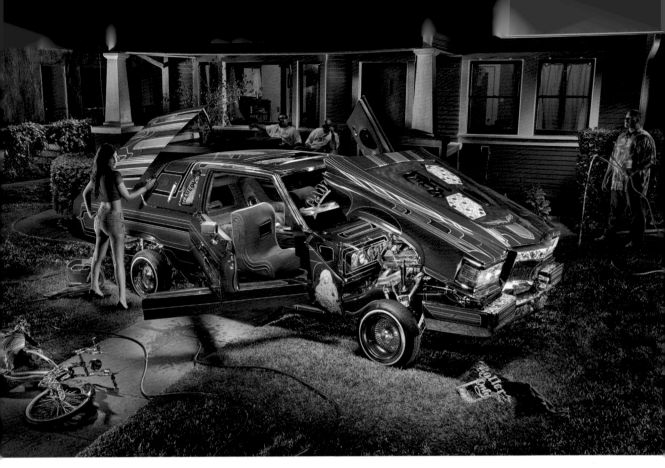

I colored the lighting below the low-rider car by adding a purple filter to my hand-held light. It suited the theatrical feel I wanted for this particular photo.

Lighting the Overall Scene. Of course, your lighting plan will have to include more than just the primary subject. You also have the ground, maybe a tree, rocks, and a back wall—or even part of a sky or horizon. These elements are part of what makes the shot successful, so they must be an integral part of your concept for the finished image. The lighting you use on most of these other elements should play a supporting role in relation to the main light source. You should not have competing, equally powerful sources, but you may want to switch between narrow sources (to accentuate texture) and broad sources (to create a soft pool of light). You should paint those elements you think add something to the photo. You do not necessarily need to cover every inch of the scene with light—but at least think about what you *do* and *do not* want to include in your shot.

You can even consider adding colored gels to background elements while painting them with light. If you were to add a little green plastic to your light while you painted some background

trees, it could add a whole new dimension to your shot. Alternately, you might add a gel to the light you use when painting the dirt in the foreground or even an old wooden fence. The result could be very striking.

While this is not a technique I employ frequently, there are several well-known photographers who have made this part of their signature look. They have added colored gels to their lights

BELOW AND FACING PAGE—Using a tightly focused beam, I can skim light across the grass or a back wall, highlighting the textures and using them as part of the composition. Other objects require a soft pool of light from my hand-held floodlight.

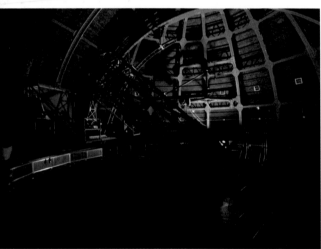

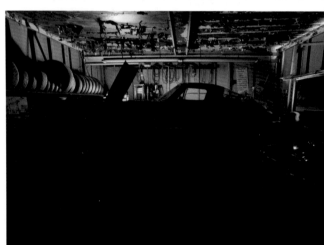

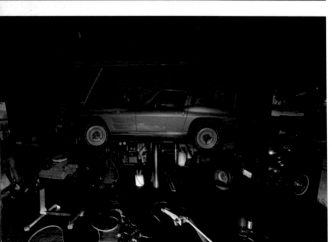

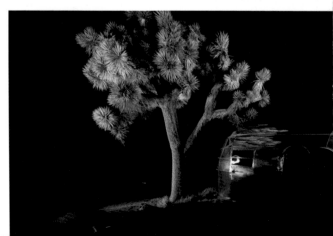

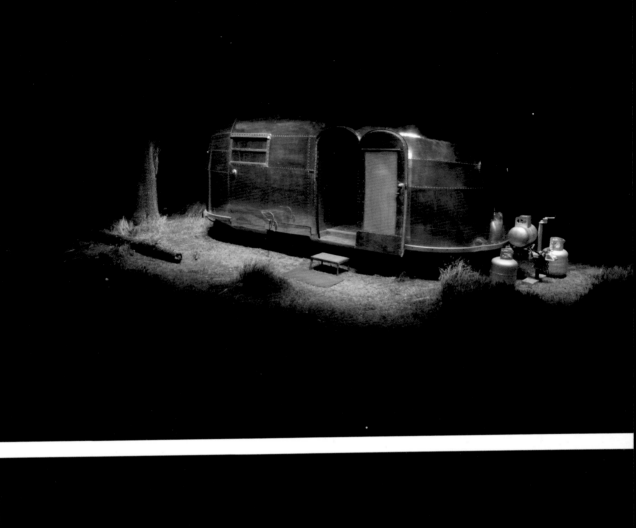

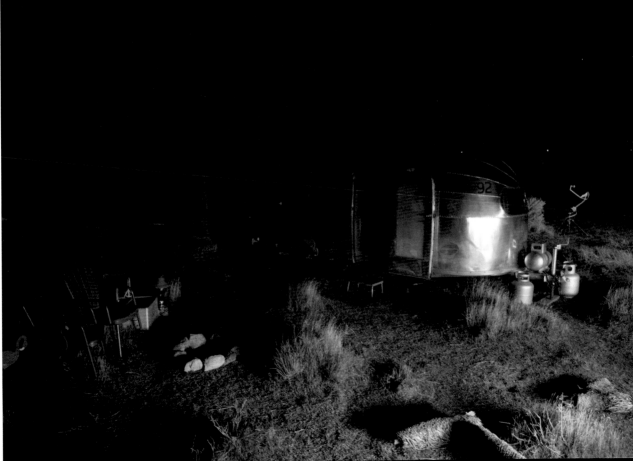

as they painted desert cacti, or added crazily intense colors to their lights as they painted old cars in a junkyard or old aircraft at night in a boneyard. The resulting shots are extremely interesting—and I'm sure they were wonderfully fun to create, as well.

Stand to the Side. A photo is, inherently, a poor semblance of reality because it's missing a dimension. Photographs have only *two* dimensions: height and width. However, when we humans look at a scene with our two eyes, we can perceive an additional *third* dimension: depth. A big part of our job as photographers is helping the viewer to perceive the three-dimensionality of the scene we are capturing. By including an abundance of carefully placed highlights and shadows, we can create the illusion of a third dimension in an inherently two-dimensional medium. This is photography in a nutshell.

To do this, generally speaking, we need to illuminate our subjects with a degree of side lighting. This creates the range of highlights, midtones, and shadows that reveal shape and depth. Think about it: the reason photos taken with on-camera flash look so flat and dead is that there are no shadows—everything is filled up with light. By selectively lighting some areas and purposefully letting other areas fall into shadow you create a much richer range of tones and textures on the surfaces you are shooting. This will help tell the story of your subject. Whether the surface is dry and cracked or bright and shiny, whether it is rounded or flat, you are trying to capture that quality through your lighting.

> A big part of our job is helping the viewer to perceive the three-dimensionality of the scene.

Lighting an object while standing near the camera creates an overall flat and "dead" image.

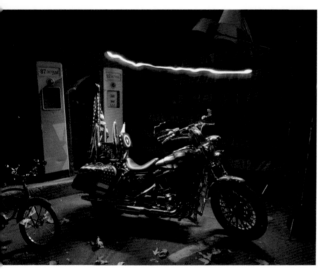

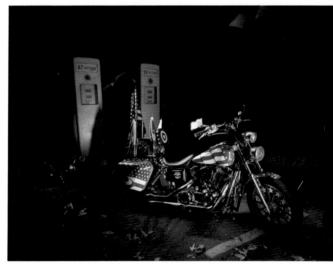

If you stand to the side or light from above, you create highlights and shaded areas on your subject, as these photos demonstrate. This adds a much fuller and richer look to the image.

So, basically, you should never light your subject while standing at or too near the camera position. We're not trying to produce that on-camera-flash, crime-scene-photo look, after all.

Hard Light and Soft Light. Just like a painter's brushes allow him to create different effects when applying paint to a canvas (from smooth strokes, to sharp lines, to pinpoints, or even rough textures), you will use your handheld light to create different effects when applying light to your subject.

The flashlights I described in chapter 1 are all basically spotlights. They all shoot a tight beam of light and are useful for pushing the light far away, such as when you want to direct light onto the side of a building or when you're trying to illuminate a tree while you

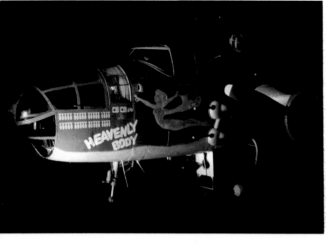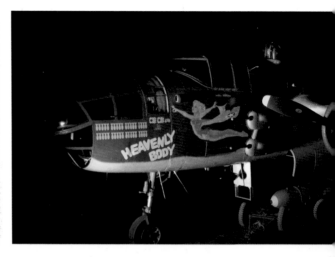

are standing on the ground. In these cases, you need to project the light in a relatively tight, focused beam onto the surfaces to be painted—without having to literally stand next to the surface.

Another use for these tight beams of light (which produce a harder lighting quality) is to reveal texture. When I want to pick up the texture of the grass or highlight the texture of the rough dirt surface, I skim a tight beam of light across it. It's also advantageous to use a tight beam when you need to project a beam of light across the exterior surface of a subject, like the outside skin of an aircraft or the face of a trailer.

Skimming the light at a very shallow angle emphasizes all the tiny elements that stick up from what might generally appear to be a smooth surface. Capturing these details adds greatly to the overall effect of hyper-realism in painting-with-light images. In

ABOVE AND FACING PAGE—By skimming light from various angles, I pulled otherwise invisible details from the surface of this B-25 bomber's nose and fuselage. I might choose to use only a portion of each frame.

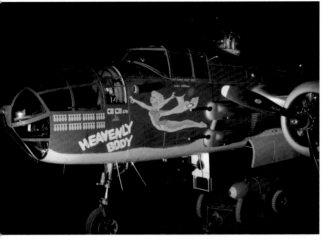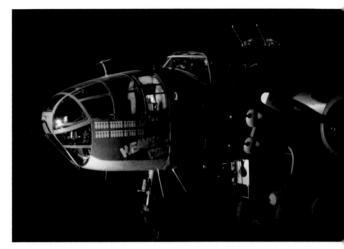
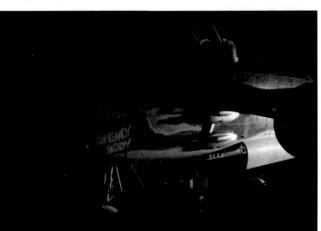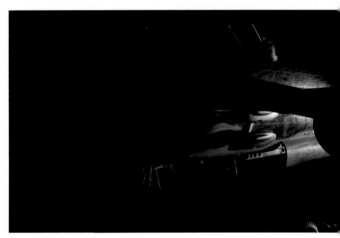

traditional photography, where you capture your subject in a single exposure, it's just about impossible to light subjects as we can when painting with light (unless you are Steven Spielberg with an unlimited budget!). Go ahead and play with this seemingly harsh light quality and pull everything you can from your subject; you can always choose not to use these images in postproduction—but it's best to get everything you can from the details and textures of your subject matter.

There is a different quality of light that is also extremely useful: soft light. Created using floodlights, soft light is the other half of the solution for making full and rich photographs. If spotlights produce a focused beam of light shooting forward, think of floodlights as bare light bulbs, spreading the light everywhere, not just in one direction.

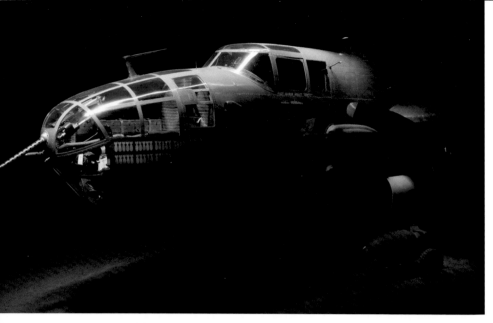

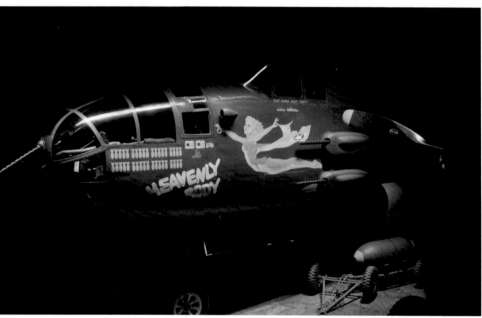

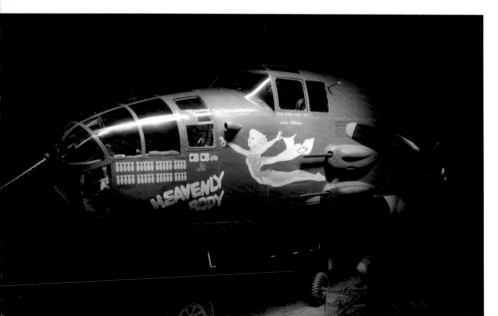

THIS PAGE AND FACING PAGE—These photos of that same aircraft nose section reveal the overall smooth and luxurious qualities of a broad "flood" of light, whether lit from above, from the side, or from below. The effect is soft and gentle, helping to reveal the three-dimensionality of the object being painted.

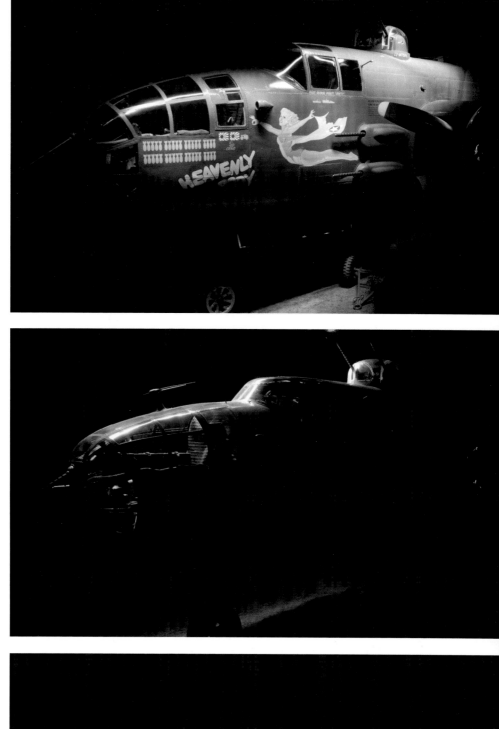
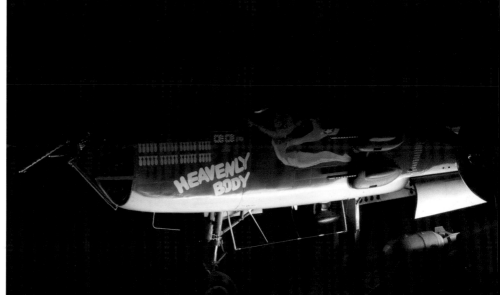

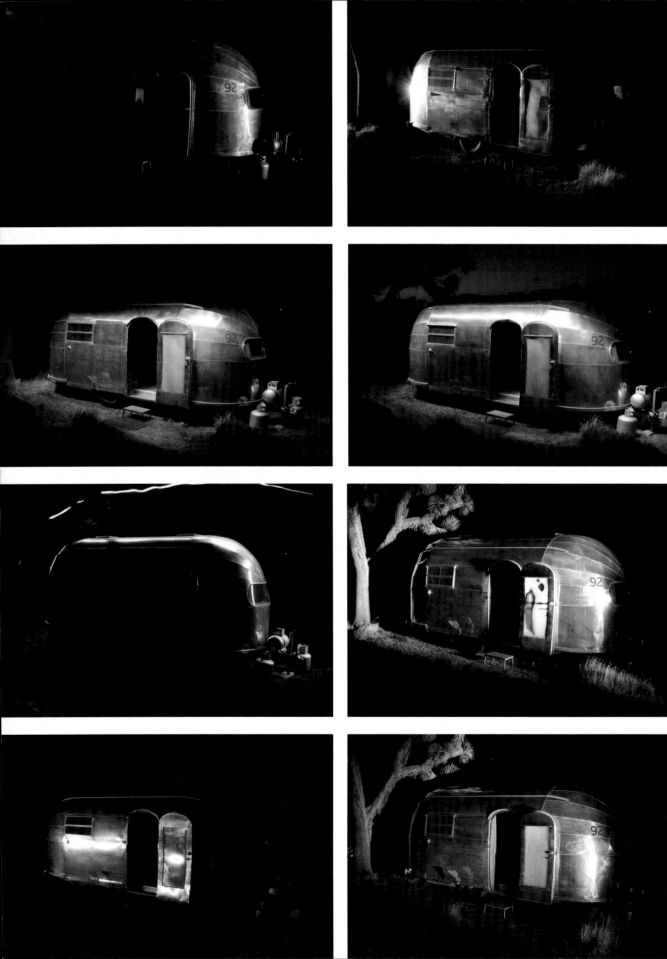

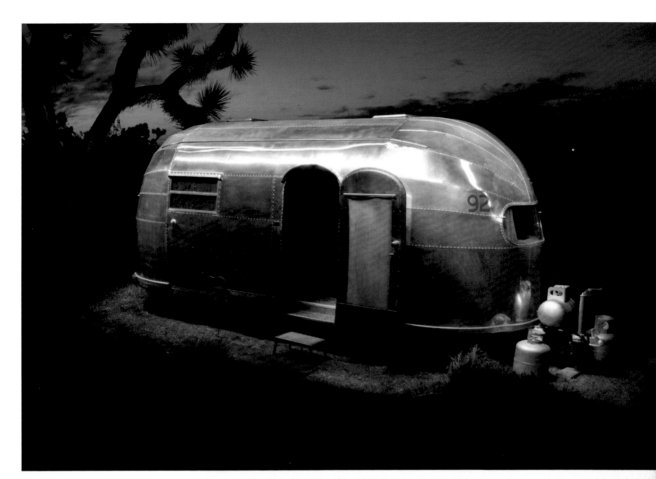

THIS PAGE AND FACING PAGE—In these different shots of the Airstream trailer, it is obvious how the quality of light from soft to hard changes the character and flavor of the surface of the object being photograph. Often, for any particular shot or exposure, I am not using the entire image but only a small portion of the frame to pull out the tiny details.

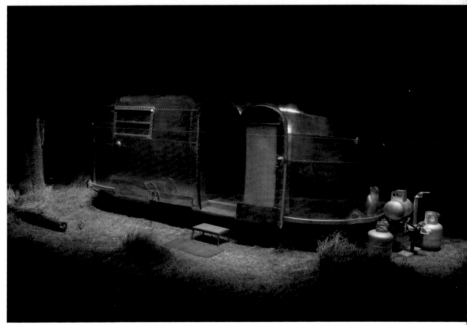

FACING PAGE—Here are several examples of different objects that were lit from above with a floodlight. In these samples, I also included a tiny bit of side-skimming light so you can see how they appear to be free-standing without the clutter of the surrounding image layers. The object stands out distinctly from the background, looking like a finished still life in its own right.

Having a very bright spotlight can also make the light harder to control . . .

Happily, you don't have to own two sets of lights to achieve the floodlighting effect. I simply spread the light by covering the head of one of my spotlights with a thin film of frosted plastic. By using varying densities of frosted plastic acetate, it is possible to turn your narrow-beam spotlight into a broad, wide-angle floodlight. Sometimes, I put what is the equivalent of a half layer of frosted acetate onto the front of my spotlight in order to broaden the beam just a touch; sometimes I apply more for an even softer look.

It is sometimes easier to use the analogy of a painter when imagining what we are attempting to do as light painters. If a car painter using a spray gun is trying to paint the fender of a newly repaired car, he will use a broad, smooth, even flow of paint and apply it over a few passes with the paint gun. Adding a few broad, thin layers of paint (or in our case, light) onto the surface of the fender will render a much better result than trying to use a narrow stream of paint/light. Especially when we are very close to what we're painting, a narrow stream sometimes results in a choppy and uneven effect on the surface.

Having a very bright spotlight can also make the light harder to control; you still want the ability to create exposures that are around 5 seconds long in order to make a couple passes, spreading your light onto the surface of your subject. If you transform your light source into a very bright floodlight by covering the head with frosted material, it is far easier to "coat" your subject with pleasant, even, and ultimately controllable lighting.

When working with a floodlight, you need to be pretty close to the subject in order for the light to actually reach the surfaces you are painting with light. It is not possible to stand twenty feet away and project this broad floodlight a great distance. That is not a bad thing; it's just different. Get up close and personal.

Lastly, you will want to cover the outside edge of the light with a snoot or some sort of tube that allows the light to travel only forward. Even on my broad floodlights, I use a snoot to prevent the light from splashing into the camera lens. Over the course of a 5-second exposure, if the handheld light is facing at all toward the camera lens, the bright path of light created by having the camera "see" the light head will cause lens flare. If the streaking created

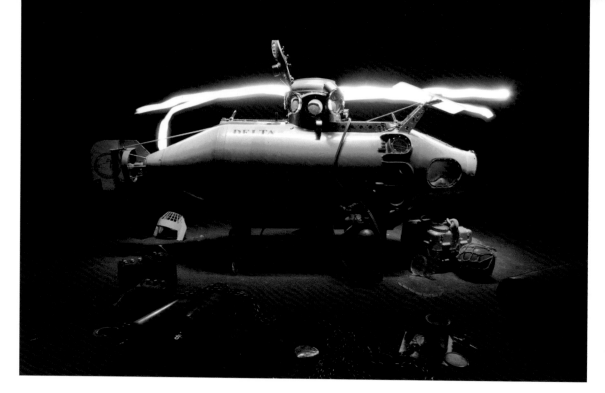

by the moving light head overlaps the surface that you're trying to paint, it can ruin the shot.

The Mechanics of Exposing Everything

I have been doing painting-with-light at an advanced level for a few years now and have learned several tricks that facilitate the process of shooting objects and scenes at night while painting with light—so please listen to my insight and save yourself some grief.

When you have a full scene (for example, an old car and some equipment scattered about), it can seem a bit overwhelming at first. Where should you start? As a general rule, I start from the center/top and work my way down, then out to the sides. Finally, I do the background surfaces and far walls. Your first exposures can be the top of your subject, if it is not too big—climb on it if you have to. Light the top of the car (or truck or jet aircraft) from above if possible.

I would light the entire top of this theoretical old car in a single 10-second exposure, if possible. I'll light the top maybe eight different times, over eight different exposures, moving my light back and fourth during each shot. When I feel that I have a good few frames of the top of the car, then I'll move on to exposing the

ABOVE—When the camera sees your hand-held light source, streaks can ruin the exposure. Try to keep the streaking head of light from touching/obscuring the subject you are painting. You can always remove the offending portion of the exposure you do not like, but it is hard to do so if there is overlapping lens flare on your subject.

FACING PAGE—In a dark environment, I can light the top of my subject and have the resulting images look like they were shot in a photo studio. This series of images shows the variations I used when lighting the Corvette from above. All the shots are similar but have subtle variations in the lighting, depending on the angle and distance at which I held the light. I might choose to use only one or two of these images.

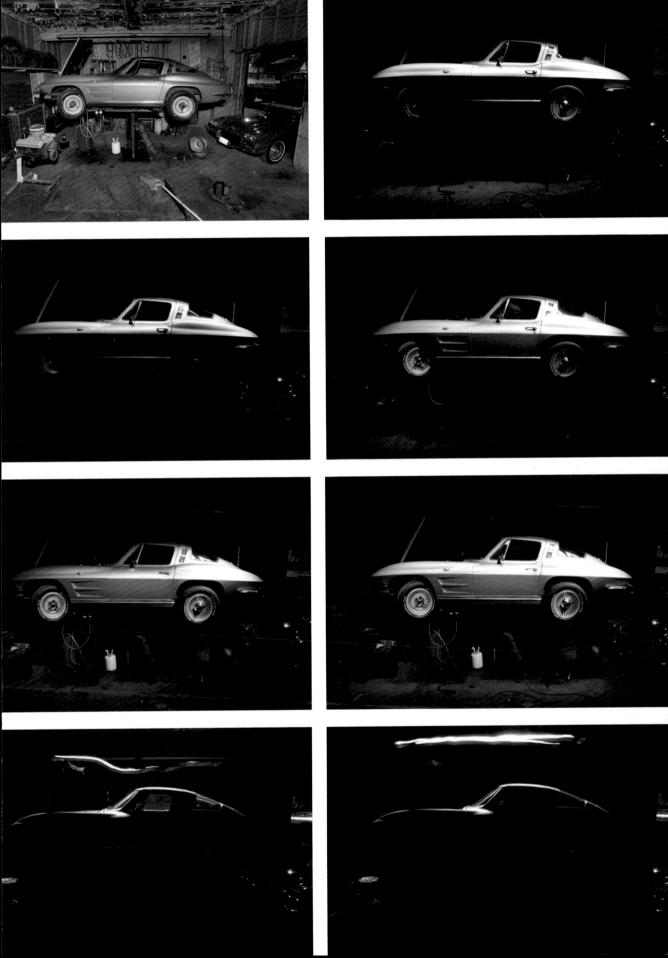

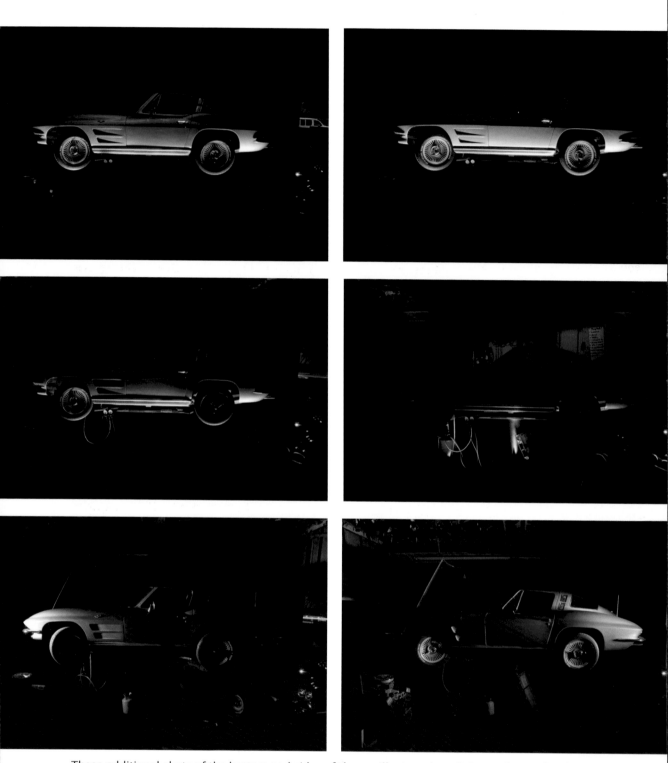

These additional shots of the bottom and sides of the car illustrate how light can be used to highlight shape and form. By using my spotlights and floodlights, I can pull out details that are usually lost (or at least overlooked) by traditional photographic lighting methods. Again, I might choose to use only a small portion from a few of these images. Notice how the light skims and accentuates the exhaust ports just aft of the front wheel well. Beautiful!

sides of my subject with my flashlight. Again, I'll do several separate exposures of each new section I am concentrating on. Eventually, I'll work my way down to the bottom edge of the subject and do the same yet again. Each time you light a new area of the subject, do a few frames or exposures of that same area so you have some variations to play with in Photoshop during postproduction.

After the primary subject is fully lit with all the ideas and angles of lighting you think appropriate, it is time to move on to the ground immediately surrounding the subject. The location where it is sitting is critically important and needs to be lit as well. Remember that these photographs we are making of neat stuff at night are not objects floating in black space. One of the lessons I learned early was that if the subject is not "attached" to the ground with an appropriate shadow splashing below it, or at least a physical surface connecting the object to the ground, it looks totally fake.

I also make a special effort to identify and light other unique features of the environment that relate to my subject. In this case,

These close-up views illustrate the importance of lighting the surrounding environment. I lit the tires in order to help the viewer see the uniqueness of this garage. Lighting the equipment below the car helped tie the Corvette to the room. Pooling light onto the free-standing engine draws the eye in a flow around the frame. Lastly, the dynamic lighting from behind and below the car added drama to the overall look of the photo.

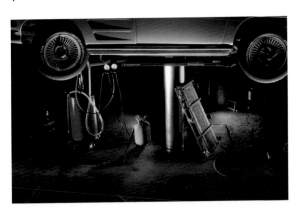
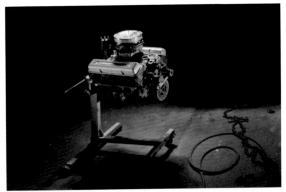

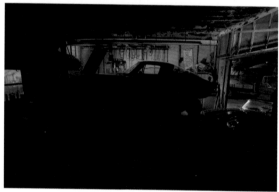

the tire rack along the left wall was interesting—so instead of just lighting the wall, I chose to highlight above and below the tire rack in order to help the viewer recognize elements that enforce this environment as the place where this cool Corvette lives.

Don't be afraid of sloppy lighting or having the beam of light bounce around a lot. I personally embrace mistakes, odd shadows, and lucky accidents in the lighting. It is often the case that one of those frames where the light splashed onto an area it wasn't intended to go ends up being critical to the overall success of the finished picture. Later on, in Photoshop, you will have the ability to easily remove any splashing, reflections, or other mistakes that were captured in the exposure. Now is the time to expose, be creative, and play with this wonderful tool and all the capabilities that are finally opening up to you with the advent of digital photography.

After the primary subject and immediately surrounding ground or surface is exposed, you can move onto the distant ground and vertical surfaces, including trees and structures. It is sometimes

These images demonstrate the division of the environment into manageable pieces. By exposing the left side, ceiling, right side/ outside, and foreground floor of this small garage, it was possible to control the light precisely. The ceiling might be made up of two or three shots combined. The floor in the foreground is made up of three or four separate images, some skimming to pick up the hoses and chains on the ground, other shots of the floor were made with floodlights to add pools of light to specific loose equipment lying about. When they overlap in layers it is possible to see both qualities of the individual shots by creating what looks like a single photo of the floor alone.

Here you can see the finished stagecoach photograph and several separate portions of the environment. I captured the dust separately with two back-lit exposures in order to highlight the dust. The tree was shot in two different frames in order to put enough light on the top portion of the branches, then the bottom portion of the trunk. Lastly, the wall on the right side was made up of about ten different frames in order to capture detail and texture from high and low areas of the wall and porch. The dog, Digger, was a lucky break, since it was not possible to move him! Finally, wrapping up with the foreground, I shot not only the right and left side of the foreground. I also lit from further back, skimming toward the front.

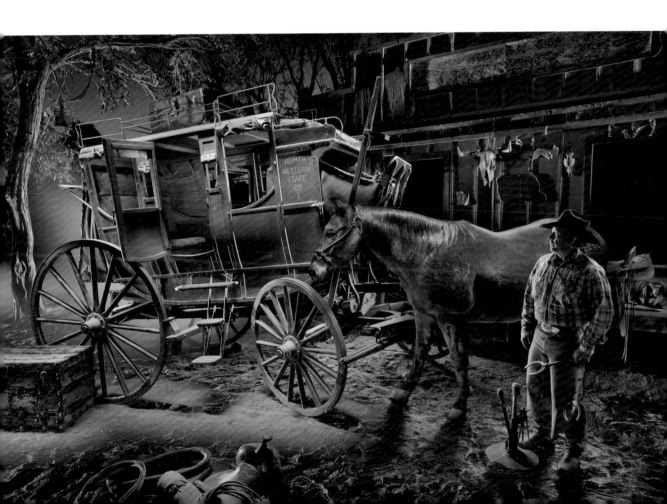

hard (and not always necessary) to actually light *everything* you see in the viewfinder. Sometimes, you want the distant ground to fade to dark or black. If so, great. Other times, you'll want to at least paint with light a single fence or wall or tree that is prominent in the scene as a compositional element. As simple as it sounds, I actually walk up to (or under) a large tree that needs to be lit and just pump light into the underside of the tree for about 30 seconds or so if needed.

When dealing with large backgrounds and big areas, you cannot paint broad areas of background with your limited lights. The light will seem weak and totally inadequate for such a big chunk of the scene. Instead, I break it into small more manageable sections. First, I'll focus my lights for 30 seconds onto a tree that I want to include, then I'll switch to the part of a wall I like, then the other half of the wall if needed.

If you have floodlights that shoot a beam like the kind I am using, you can skim your light onto different areas of the ground and break that into separate exposures, too. I'll usually skim my light onto the right side of the foreground, then do the left side of the foreground, then move further back. I recommend shooting far more frames on location than you'll actually need. You're like a painter mixing a palette of colors before he paints.

Over time, it becomes easier to remember what you exposed and what you missed. Still, it can be challenging to remember absolutely which areas have been covered because I am spinning, twisting, and running around from the front to the back of the scene. With smaller sets, it's less of a problem, but as your environments get more ambitious, your own internal navigation can get a bit convoluted. In these situations, the person opening and closing the camera can help keep track of it all. That person has the advantage of sitting in one spot and looking at the scene unfurl over time, so I often rely on my assistants and camera operator to remind me of any skipped portions of the photograph. It's amazing that the mind can view, process, and store the previous three-hundred exposures over the course of four hours and still come to the correct determination that, "You missed a section from the far-left corner of the shot!" After a couple shots with the

I recommend shooting far more frames on location than you'll actually need.

Here are four examples of existing-light sources for you to utilize. Consider these sources "freebies," in that they add depth and character to your photo—and you only have to expose them, not create them. Whether it is ambient street lighting in the distance, sunset horizon light, neon lights from a sign, or even brake and parking lights on a vehicle, including these ambient sources helps your photo seem less contrived. After all, it is hard to fake a street light!

same helper, they are almost expert in this skill—and it is nice to have help on location with me.

Include All Existing Light Sources

I always include the existing light sources that occur naturally in the frame. The details revealed by extraneous light sources add a lot of character to any scene. After all, we are not trying to create a shot in a vacuum. You are in this particular location for its character and aesthetic.

These light sources could include an overhead fluorescent light, street lighting, or a neon light at the location. When you do your light painting, you will turn off those lights—but at some point during the shooting session make sure to include several exposures with those lights turned on.

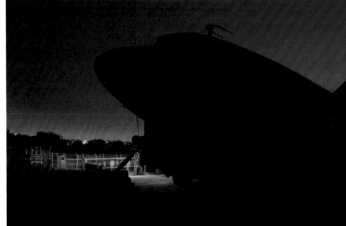

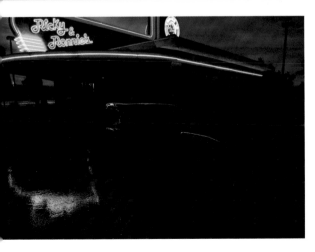

This also applies to the brake and headlights of an automotive subject—as well as any other light sources you can utilize to add richness and detail to the photograph. Tossing some dirt into the beams of the headlights will help define the cones of light and give you something to actually shoot if they are pointing out of frame.

I also put moonlight in this category. Usually I want to overpower any ambient light I cannot turn off. With moonlight (and strong lights for painting), this should not be a problem. But after you are finished, be sure to include several frames of the overall scene lit only with the moonlight—or, similarly, the overall light of the surrounding city, if that is present.

Make several exposures with the ambient lighting and bracket the heck out of them. Also, play with different color balances in the camera settings; you never know what will work. When you compile the scene later in Photoshop, you just want to have at least one good exposure that includes the overhead lights. Be sure to keep those exposures separate from all the other painting-with-light frames so you can play with them separately in postproduction.

Get Physical, Stay Focused

The process of capturing all these different exposures can be quite demanding physically. If you are working on a small set or small still-life scene, it is no big deal. For these shots, it's easy to move from the right side, to the left side, then light from above, then step behind the subject and make another.

If, however, you are shooting a larger scene, the process can turn into a pretty good workout. For most of us, this will be a big change. Photography is often a relatively sedentary experience—sitting or standing in place, shooting away casually as we ponder framing and exposures.

The painting-with-light experience is totally different. When you get to the point where you are starting to expose your night scene—when the camera is mounted, the lights are ready to go, and you shoot what might be the first of dozens of exposures—something shifts in your mind-set. I think it is the quest to capture your prey. It can be a challenge to get it all while on location, and you do not want to go home empty-handed. As we start to expose

Make several exposures with the ambient lighting and bracket the heck out of them.

This very long exposure of an abandoned tractor lit with only moonlight is ethereal. It almost looks like an overcast daytime shot—except that you can see the stars as pinpoints of light in the sky. During one of those long exposures, I can paint light onto the tractor with a small flashlight (bottom) and create something that is interesting and unusual. The possibilities are limitless.

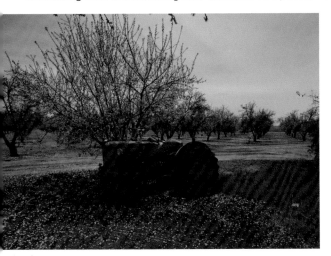
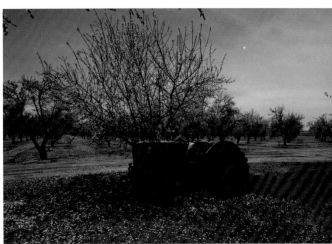

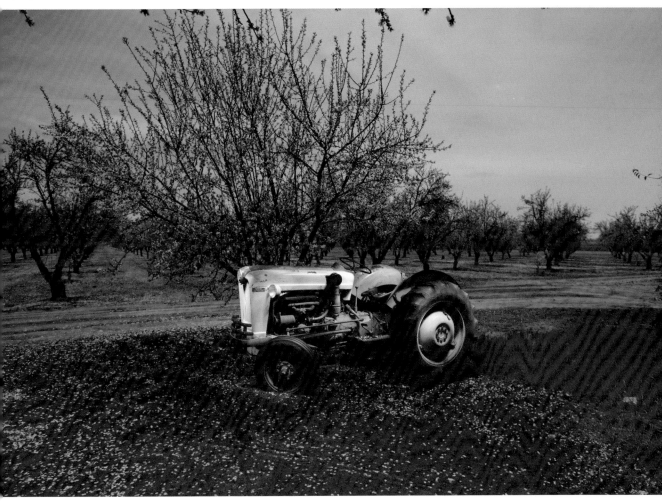

the first few frames, I like to take a deep breath, compose myself, and bring myself down to the here and now—to literally live in the moment. The only thing in the world is this photograph and the light painting that is happening right now. I keep in mind the story I am trying to tell in this scene and how the light will promote that vision.

As a result, I find myself working hard to get every frame I have envisioned, to capture every variation and cover all my bases to ensure a successful recombination later on. Personally, I love the pure physicality of the process; it is part of the overall experience of being on location. You only have so much time to spend and it's a challenge. It's normal for me to work up a full sweat and have to change my shirt once or twice in order to avoid getting chills (remember, these shoots are usually done at night—and even in the summer, the night air can be quite cool). I certainly recommend pacing yourself. Take a break here and there, have a drink and rest. If you become overly tired, you can lose your focus and perspective, so stay fresh and keep creative.

If you become overly tired, you can lose your focus and perspective.

4. Adding Human Subjects

Y ou have made it through the meat and potatoes of this technique and should now have a good grasp of the mechanics of painting light onto an object and the environment. Adding human subjects to the equation is a bit tricky, but it follows the same basic principals as the other sections you have already read—with one major complication: movement.

People Move!

When we use painting-with-light on an object, we move the light from the right side, to the left side, and maybe position it above and behind the object as well. The intention is to create a palette of exposures that can later on be stacked on top of each other in Photoshop, resulting in a single wonderful photograph.

If you shoot several different frames of, say, a miniature submarine, it's clear that you can light it from all directions over the course of a couple of hours and all the individual frames will line up with each other. Since your camera is on a tripod (and nobody kicked it), the first frame you shot early in the evening will still line up with the frame you shot two hours later. This means you are free to mix-and-match any of the exposures you captured in order to get the exact look you envisioned for the subject and its environment.

The problem with photographing people with this technique is that they move. A person cannot hold still for very long—much less for hours, like a static mini-submarine. When putting a person back together in Photoshop, it is my experience that the right-side exposures of the person do not necessarily line up with the

The problem with photographing people with this technique is that they move.

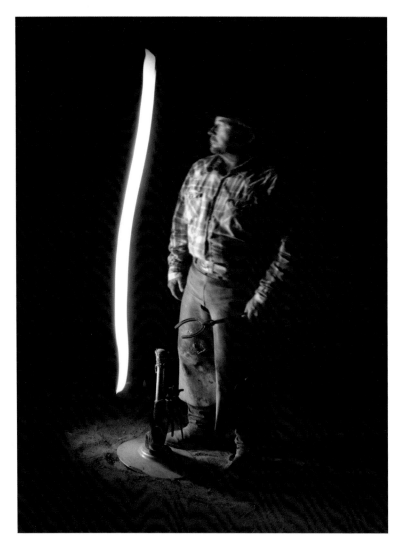

This exposure was too long (5 seconds), and my cowboy subject moved slightly during it. While his feet are sharp, his torso is blurry because he had nothing to hold onto or lean against.

exposures of the left side of that same person, especially if there is too much time in between exposures.

This adds to the complexity of the challenge: the final version of my mini-submarine image might be made up from thirty different exposures. With a human subject, I'll probably have more like one to five exposures total. Beyond that, the movement of the person's body parts between the first exposure and the last exposure will make it impossible to combine the images seamlessly. What to do?

Nobody is captured in mid-stride or while jumping through a doorway.

Design a Stable Pose

In my photography, the power of the persons depicted does not come from freezing a powerful moment. Nobody is captured

in mid-stride or while jumping through a doorway. Instead, the power comes from the integration of the human subject within the overall scene and from the lighting.

What works well for me is quite simple—in fact, it might even be described as a bit old-fashioned (refer back to the introduction and consider how early photographers, who also needed to use long exposures, dealt with the issue of human movement). Essentially, I look for ways to stabilize the subject's pose. When a person is sitting or leaning against a stationary surface, they have a place to be. That makes it far easier to hold still. It gives you more time to light all sides of your subject, and it gives the subject the ability to "feel" if they are moving out of position.

Even if your subject does not have an object to sit or lean against, it is nice to have an object they can feel a bit—one that touches

Essentially, I look for ways to stabilize the subject's pose.

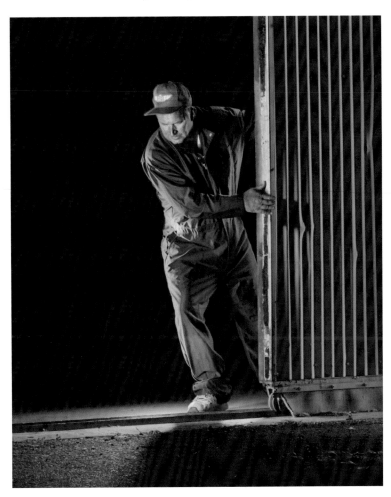

Giving your living subjects something to grasp, sit on, or lean against greatly increases your ability to create sharp exposures of people. Exposing people with continuous lights can be tricky.

their body, like a part of a fender or a piece of equipment. This lets them "feel" where they are supposed to be and better hold that position for the 1 or 2 minutes you are exposing the different parts of their body. Anything that is stationary (doorways, aircraft hangars, large tools) will help them maintain a static pose.

Another simple technique I employ to help my living subjects remain stationary is to position a stand behind them with one or two protruding rods reaching out to touch the subject. This technique, borrowed from the early days of portrait photography, sounds almost ridiculous but it works. I place the stands behind the subjects, so the lens does not see too much of the structure. Instead of "grabbing" my subjects with claws or clamps (I'm not a monster, after all!), I allow the two protruding rods to simply touch them. This gives them the ability to feel where they're supposed to be. Over the course of a minute or so, while I am exposing various sections of their body, the stand gives them a reference for where they started and helps them maintain that pose to within a fraction of an inch. If they start to drift out of alignment, they can feel the force of the rod touching them. It is a surprisingly simple, low-tech, and effective solution.

If they start to drift out of alignment, they can feel the force of the rod touching them.

These two successful frames of my fireman subject were exposed for only 2 seconds each. The ladder was attached to two stands in order to make it solid and stationary.

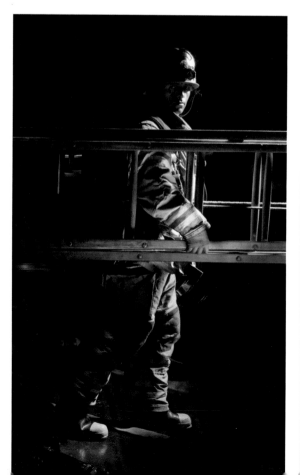

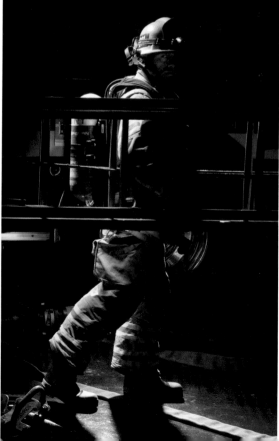

The two halves of the fireman can be combined easily as there was very little time between the exposures, and my subject remained in alignment. Notice that I am conscious of the lighting on the subject and trying to blend this light into the overall scene.

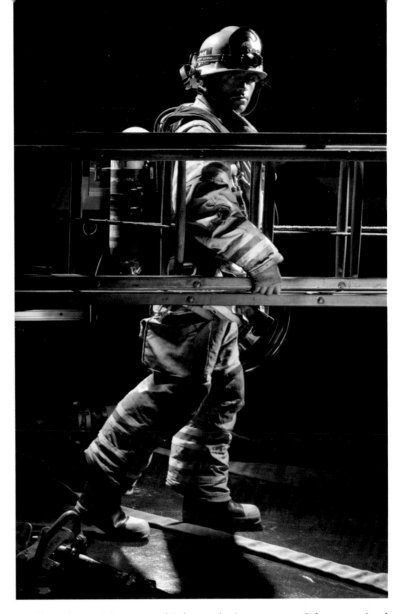

Nobody will see this slight movement in the final images . . .

Shooting with a very high-resolution camera I have noticed that the exposures of the bottom portion of a person are generally sharper than the portion of a person near their head. This is because the feet and shoes are locked and stationary on the ground, while the shoulders and chest are actually moving ever so slightly as a person breathes! Nobody will see this slight movement in the final images, but it's fascinating to see it on my monitor.

Light in a Single, Smooth Pass

While lighting sections of people, you do not want to move your light back and forth a few times for each exposure as you might

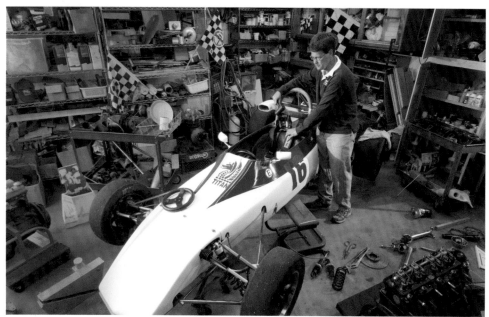

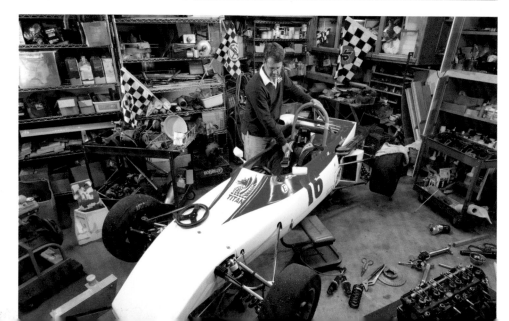

I generally do not like to change the aperture as that might change the critical focus.

when lighting a piece of car or a portion of a building. Instead, try to make single smooth pass with your light—one time only for each frame exposed. If you are lighting the left side of your subject, for example, make the light travel from the bottom of his shoes to the top of his head in a single movement with your light over the course of 1 to 2 seconds. If you have a strong enough light, this is totally doable. Create two or three different exposures, then move onto different sections of your subject.

While I have previously advised you to not touch your camera after you've started shooting, when photographing people, I usually increase the ISO up to about 400 or 500—sometimes more. I generally do not like to change the aperture as that might change the critical focus, and (of course) you should never change the focusing from when you started. It is, however, okay at this point to increase the ISO so you are sure to get the people in quick, clean exposures with as short an exposure on the body parts as possible.

Lighting People with Strobes

Another option is to set up two or three strobe lights around your human subject and freeze them with one overall shot. This is definitely an option if you need to make a really clean capture

BELOW AND FACING PAGE—When photographing people, it is definitely an option to light them with strobes, then use the painting-with-light technique on the rest of the scene. That way, you only have to blend your living subject back into and on top of the reconstructed scene.

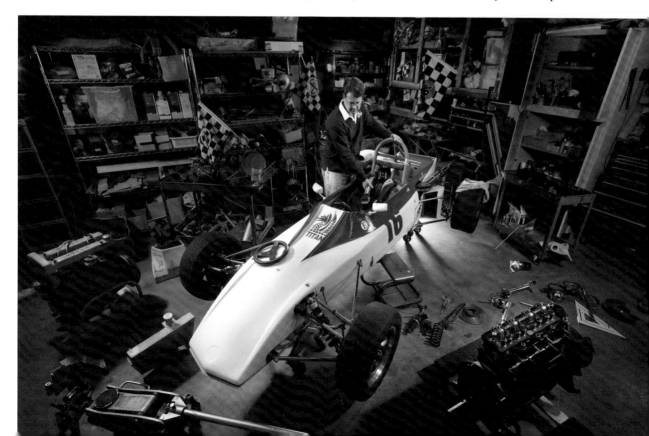

of your subject in one shot and ensure he will "fit" the rest of the scene. When setting up a shot with strobes, make sure that the lighting on the person is totally balanced (right side, left side, top, and bottom) in each exposure. After the fact, it is hard to change the basic exposure on his left, for example, to make the subject fit into the overall shot you have previously painted with light.

With this approach, you gain the advantage of not having to go through the bother of recombining the body parts back together again as you would with a continuous-light sequence of painting-with-light captures. However, you have the added hassle of needing to bring additional sets of lights—and all the corresponding equipment (packs, stands, umbrellas, extension cords, etc.)—to the session.

When I do these shots on assignment for advertising clients, there is a budget for strobes, paid assistants, and vans to haul all the necessary hardware. When I'm shooting for myself or on smaller jobs, painting the subject multiple times with one continuous light source is easier overall. For these sessions, I like to keep it simple and enjoy the process of painting with light.

I like to keep it simple and enjoy the process of painting with light.

Postproduction

The last thing to keep in mind is that the postproduction process will be a bit different. Since the human subject will not be present in the scene during the entire painting-with-light process (they are usually added in at the end of the session), they will have part of the original scene visible behind them. Darkening that area just a bit in the postproduction process makes it easier to put a person into the scene. If you have a lot of detail behind the person, consider adding a solid black mask matching the outline of the person's shape as a separate layer. At the end of the process, you will wind up with the "person" layer you created stacked at the very top of your layers palette, then the black mask of the person just below that (to block the background object from showing through). All the layers that make up the rest of the scene you painted with light will appear below these two layers.

5. Postproduction

It is often the case that photographers dislike Photoshop processing or consider it drudgery. I understand that. I sometimes share those same sentiments—but not in this case. All that you have accomplished so far, all the planning and night shooting, have been leading up to this point. This final aspect of combining the separate elements you created on location is an exhilarating and rewarding process. Best of all, it will open up your mind to a new world of possibilities.

Finally, it's time to create something that is greater than the sum of its parts. You will be making photographs that have never been seen before, a process that is rewarding and super-creative. I relish and very much look forward to this final step, the culmination of all my previous work. If you are not in a hurry, it can be very much a Zen experience. Get into the zone in your head, take your time, explore the different looks you can create using various exposures to change the character and flavor of the overall shot. And here's my biggest tip: *save your work often!*

You will be making photographs that have never been seen before . . .

Image Editing and Management Software

There are several different types of software out there that will help you deal with the large number of exposures you create when shooting these painting-with-light photographs. It is not unusual for me to shoot hundreds of different exposures on location in my attempt to fully capture all the separate elements of a scene. (Yes, I'm crazy and have clearly gone over the edge.) You do not need to be so rabid about the whole thing, but you might still

find an image-management program helpful when dealing with the exposures you create.

In the past, I used Aperture for this purpose, but I recently made the switch over to Adobe Bridge. With this program, I can quickly scan through all the exposures made on location and get a sense of what I have to work with. During my edit in Bridge, I scrub through the photos, looking at large thumbnails of the individual shots, then pick out the best exposures of a car fender, for example. As I select different groups of images (left fender, top of car, horizon light, etc.), I do a critical color correction of the files selected, label them, then move them to the folder I will use for creating my masterpiece.

It is nice to have different groupings available in that folder. With all the components of the scene clearly labeled, I can grab a set of images and use only the best frames for each portion of the subject. Of the perhaps seven shots selected and color-corrected for the left fender, for example, I might use just one or two in building up my shot. Naturally, I have the ability to go back to Bridge at any time and view *everything*, in case I am missed any portion of the scene.

This screen shot of my monitor shows Bridge running. The large image at the top is an exposure I might want to adjust or view in detail; the frames scrolling along the bottom are different images I made on location. Bridge is very useful for managing large numbers of exposures.

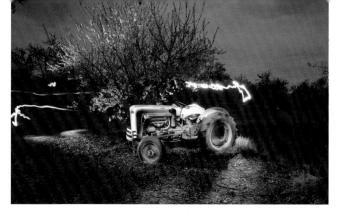

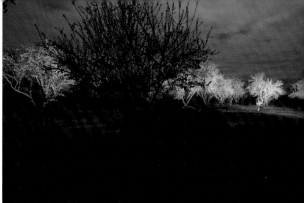

It is absolutely possible to make a combination photo with only two or three separate exposures. Here you can see that, with just a few frames of the tractor at night in the field, I was able to produce something pretty unique. It does not have to be complex. Keep it fun and easy.

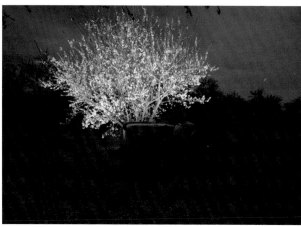

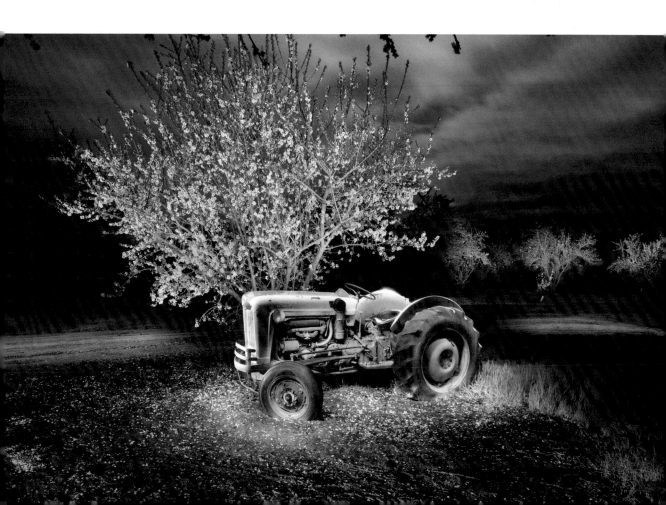

Using Photoshop to Recombine the Images

Let's get the bad news out of the way first: After the initial photography is completed, it usually takes me about fifty hours to recombine all the desired images back into a single photograph. Keep in mind, however, that I'm a perfectionist and it's not uncommon for me to shoot eight-hundred separate frames on location, and to use two-hundred or more of those exposures in my final image. That's a lot to manage—and a lot of choices to make. I want to emphasize, though, that this technique *does not have to be this complicated*. It is absolutely possible to make a painting-with-light photograph with only two or three Photoshop layers (exposures). For myself, because the concepts and settings are so very intricate, I tend to go a bit overboard here and there—but it is by choice, not by necessity.

I tend to go a bit overboard here and there—but it is by choice, not by necessity.

Creating the Layers. The basic layering process in Photoshop is simplicity itself. Start by opening one image in Photoshop, keeping it at the camera's original size and resolution (don't change it). Next, open the layers palette (Window>Layers).

I like to start with a piece of a distant sky/horizon that is dark, so most of the image will be dark. Alternately, I start with a very dark exposure that has a piece of the primary subject lit from above in the center. Basically, I am using the middle of my main subject

This is one image opened in Photoshop. The layers palette is opened, revealing the only layer so far.

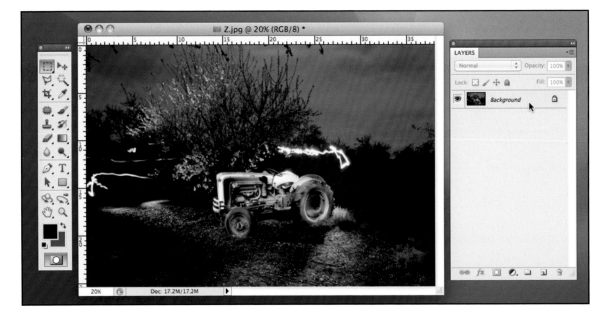

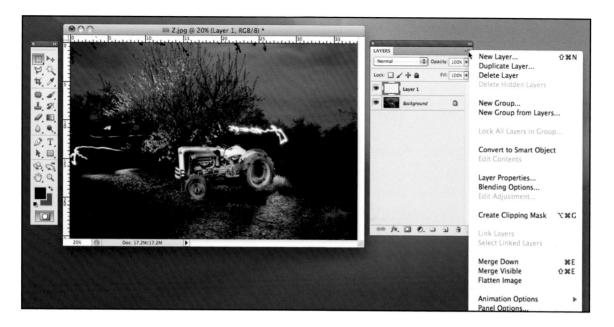

The new layer you create starts off at the top of your stack, but you'll drag it to the bottom and fill it with black.

and building it out and down—so it is nice to have a recognizable exposure that I can reference as I make it larger by adding layers. If I started with some obscure corner of the image, I would not have a good sense of whether the image was progressing properly.

Now that you have a first layer, it is easy to add another layer. Go to the top right corner of the layers palette and choose "add layer" from the pop-out menu. Even though the layer will appear above your first image layer, you want it to be at the bottom of the stack of two layers. To do this, you must first double-click on the bottom layer to unlock it. Then you can simply drag the new layer you created into position below the background layer (now called "layer 0") in the layers palette.

The next step is to fill in that new bottom layer with solid black.

The next step is to fill in that new bottom layer with solid black. You can do this simply by painting in black everywhere, or (with the new bottom layer active) go to Edit>Fill and select black in the contents field. You'll notice in subsequent screen shots that I also re-named this layer "black"; you can do this by double clicking on the "layer 1" text in the layers palette and entering the new layer name.

Returning to the first image that you opened in Photoshop (now the top layer), use the Eraser tool to remove any parts of the image you do not like. In this case, I erased some streaks of light that

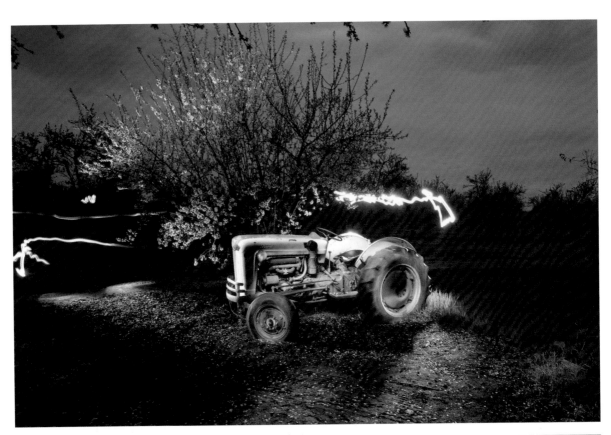

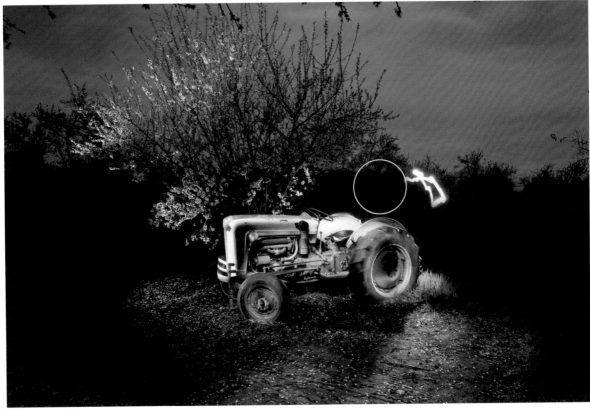

FACING PAGE—Here are before and after views of the light-streak removal.

were captured by the camera during the exposure. If I happened to accidentally paint light onto myself or my shoes, I'll remove that portion of the image, too. Basically, you want to remove any portion of that exposure that you did not intend to paint with light. Often, you will wind up erasing all but a relatively small portion of the original frame; everything else will be removed.

When doing this erasing, be sure to use a very soft brush. You do not want to use a sharp-edged eraser that could leave harsh edges that will make the composite look artificial. You don't want to make it look as though you cut-and-pasted these images on top of each other. You want all of the elements to blend pretty evenly together as the final photo grows from shot to shot. Do your erasing smoothly and evenly over a wide area, with no harsh or abrupt erasure between your individual components.

Now, it is time to add another one of your exposures to the stack of images in the layers palette. You can choose an image in which the light-painted area is completely different than in the previous image. However, I think it's fun to see how two images have different lighting effects on portions of the same subject, so I usually choose a second shot in which the light-painted area overlaps with what was in the first shot.

It's fun to see how two images have different lighting effects on portions of the same subject.

With your next file open, you can copy-and-paste or drag-and-drop the new image into your layered working file, where it will automatically appear on a new layer. You'll use the same procedure to keep adding new layers (additional exposures with different areas lit) to your composite. As you add or drag each new image, placing it at the top of the layers palette, you need to make sure that it is correctly lined up with all the previous images. If you select the entire image (Select>All), then copy and paste it into the file, the layers will line up automatically. If you click and drag the new file into the layered image, pressing and holding the Shift key as you release the image will force it to align to the underlying layers. If the new image isn't exactly lined up with the previous images below it, go to View>Snap, then click and drag the layer into position. The Snap function will cause the layer to click into place as it nears the border of the underlying photo. It is convenient and pretty neat.

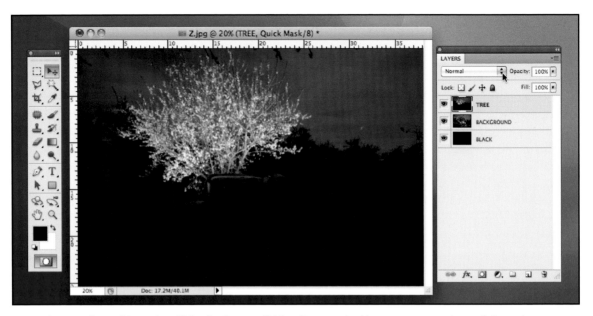

Here, the new "trees" layer is still in the "normal" blending mode. You cannot see through it to the tractor photo underneath. It just looks like a regular exposure you shot on location.

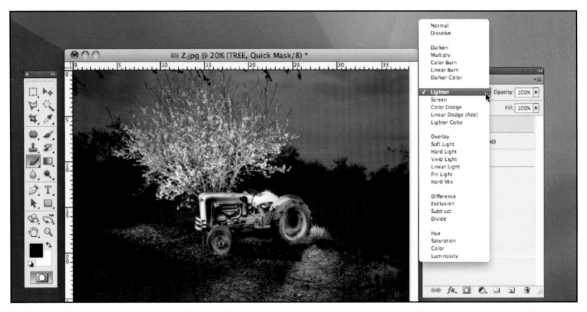

Switching the "trees" layer to the "lighten" blending mode allows you to see the images underneath. Notice that the whole image is not clear, though. You only see underlying detail that is lighter than what's on the overlying layer. This is why you want to keep as dark as possible everything you do not purposely choose to include; these dark areas will drop out automatically when you switch the blending mode.

Now that you have added a second new layer to the stack of exposures, you will see that the new layer is on top of the previous image. It appears as a normal image and you cannot see through it. If you lit it well and did a reasonably good job of exposing the image when you were on location, you should have a dark background with only the portion you painted with light standing out as a well-lit area. If you did a *really* good job, the rest of the frame should look totally black except for the portion you painted. Now is when it gets really fun! Before you start to erase or remove portions of the new photo you do not like, go to the blending mode setting near the top left of the palette and switch from the "normal" mode to the "lighten" mode. Surprise! The new top layer that was opaque has become transparent—but only transparent in the areas where the overlying image is darker than the underlying image. Now, you can see through to the photo underneath. As you play with new layers, stacking them on top of previous layers, go ahead and play with different blending modes; the ones I use most are lighten, screen, and overlay. Try them all and get a sense of what effects are at your fingertips.

At this point, you can erase any portions of the top layer that you do not like, blending the image data on this layer with the underlying image. Where your light painting overlaps from one

> The new top layer that was opaque has become transparent . . .

> Stacking the individual images in separate layers lets you build up photographs using controlled separate exposures you painted with light. You'll truly be creating something that is greater than the sum of its parts.

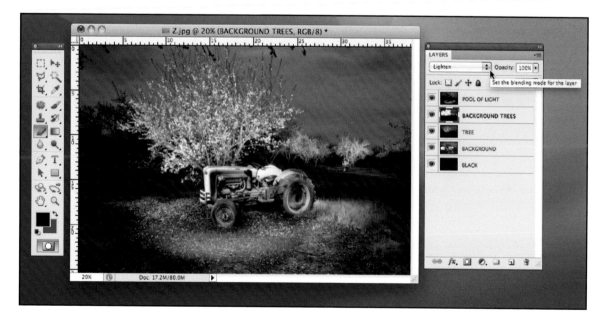

frame to the next, you can delicately remove (erase) any portions of layer that may be causing a problem with too bright a highlight or reflection.

Using Photoshop to Recombine People (Dr. Frankenstein)

If you did a good job of exposing the images, the process of recombining your exposures of a human subject should be straightforward and not much more difficult than combining exposures of other static objects, as we've been doing so far.

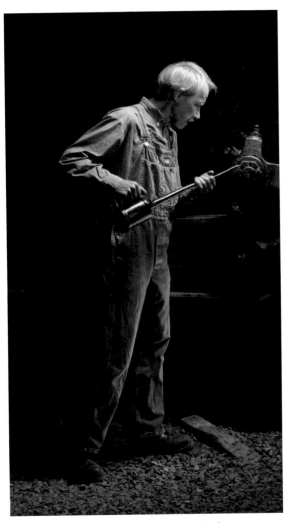

Here, the subject was lit from only the front.

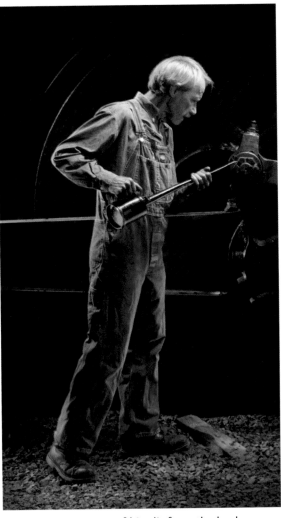

Adding an exposure of him lit from the back created a full and rich view of the subject in the environment.

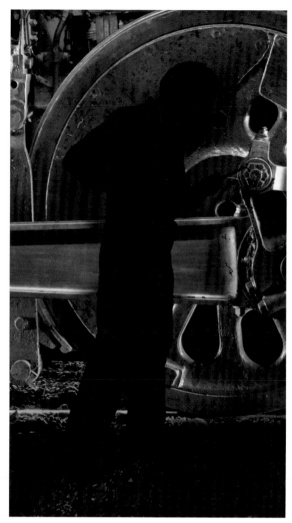

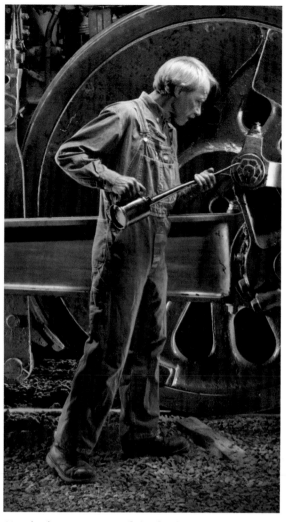

Adding a black silhouette of the man, on a separate layer at the bottom of the stack of "person" layers, prevents the train from being visible through him.

Here's the same area of the final image with what appears to be a solid subject standing in front of a train.

However, as you become more ambitious in your photography, you'll probably find that you want to use poses that can't be perfectly stabilized. (*Note:* Refer to the previous chapter for some tips on optimal posing and lighting that will facilitate the recombination process.)

When starting to "make" a person, I look for the cleanest, biggest piece of my subject that is well-exposed, not blurry, and has the best composition. I'll then add new portions to the subject until he or she is complete. As you add new portions of your living

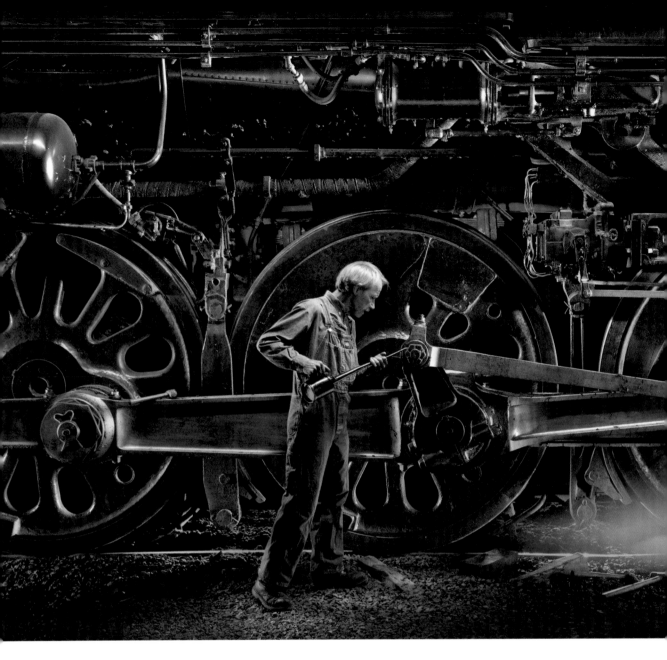

subject, be sure to change the blending mode to "lighten" so you can see through each new body part, adjusting how they overlap and align with each other.

It is not unheard of for me to actually cut up or very slightly move an arm or leg in order to make it line up exactly with its equal on the opposite side of the body. Since I light my subjects with what is basically right-side and left-side light, if a body part moved in between exposures, a leg or arm is either too wide or too thin when recombined. Cutting out the offending portion of the

Here is the completed scene with all the elements balanced. Can you see how the human subject fits homogeneously inside the environment? Even though he is only made up of a few exposures, the lighting on him does not appear inappropriate compared to the very complex effect employed on the rest of this steam locomotive.

appendage and slightly nudging it into place improves the look. But, all the while, I am matching every new portion to line up with the original exposure I selected of the subject. This gives me a consistent point of reference.

When re-creating a person in Photoshop, I find it helps to turn off the photo you have made up to this point. Leaving it on only adds visual confusion and clutter, so I like to simplify the scene and work on a solid black background. This makes the body parts stand out more clearly so I can see when something looks strange or disproportionate.

After you have "made" your person, a process that will usually involve combining two to five exposures, create a new layer and place it at the bottom of the stack of "person" layers. On this new layer, you will make a simple black silhouette that is in the shape of your person. You can use the Airbrush tool to paint an area the shape of the person in solid black, or make a selection in the shape of the person's outline and fill it in with solid black. This new layer is going to keep its original "normal" setting in the blending modes. Adding this opaque black shape below the person you created will keep the overall scene from showing up through your person. You do not want to see through the human subject to the car or tractor behind him. This black shape prevents that.

The final step is to make sure your living subject balances visually with the overall scene. Often, after the overall shot is finished and fully combined, I play with the contrast and color settings to ensure that the person and overall scene appear homogeneous to the viewer. Nothing should stand out in the overall scene as looking "wrong." What you are selling to the viewer is the story in the photograph, not the contrast of a subject or a person. Everything has to work together in order for the shot to be believable. If any particular area of the photo appears as though it is manipulated, viewers will dismiss the photo as being fake.

6. Practical Examples

I want to share with you several of my favorite painting-with-light photographs. In these sequences, you can see the progression as I add layers to the existing file. As you watch each new layer develop, keep in mind that I have already color-corrected the shots, made any necessary exposure adjustments, and removed any flaws in each new portion. You are only viewing clean, finished frames as they are stacked on top of each other.

Corvette

An overall rough image of the Corvette.

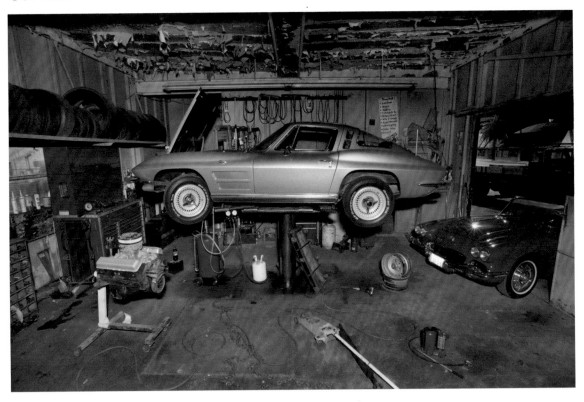

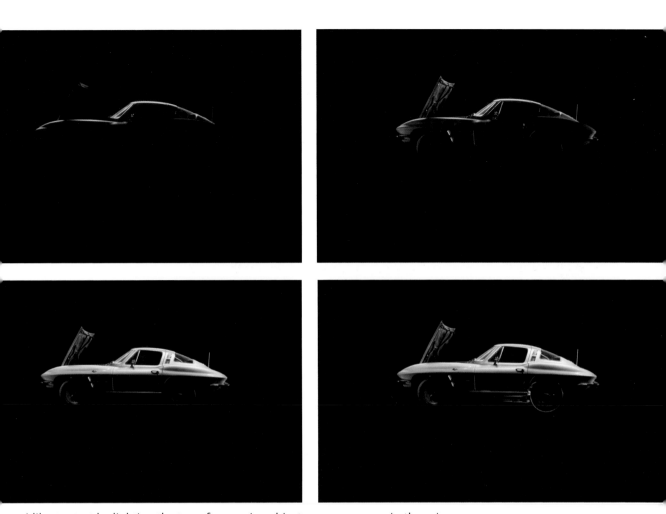

I like to start by lighting the top of my main subject, as you can see in these images.

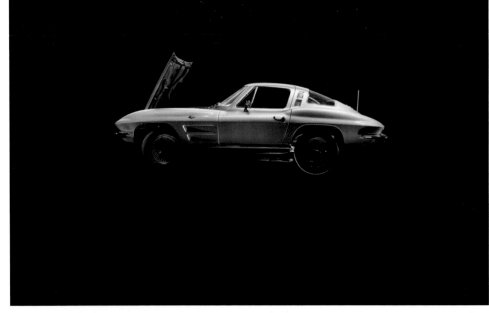

After lighting the top of my main subject, I like to work down and then outward. Here you can see the sides of the car materialize.

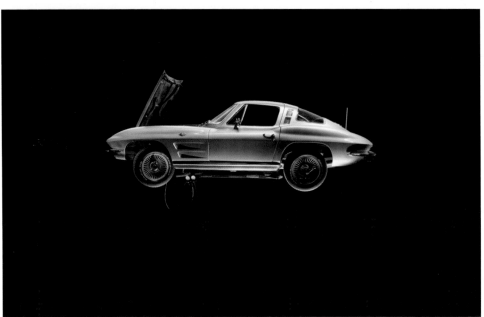

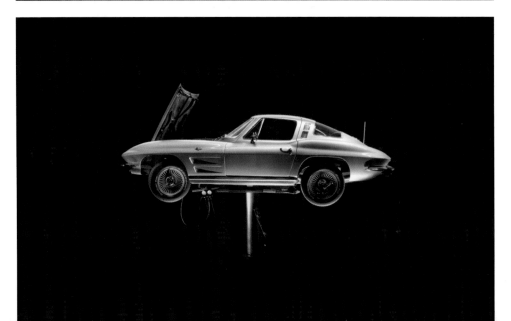

Continuing
on, I'll include
portions of the
environment
under the car
and surrounding
areas.

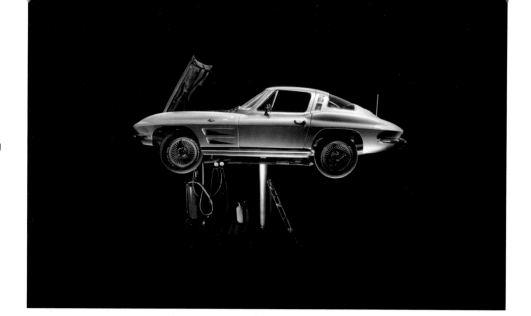

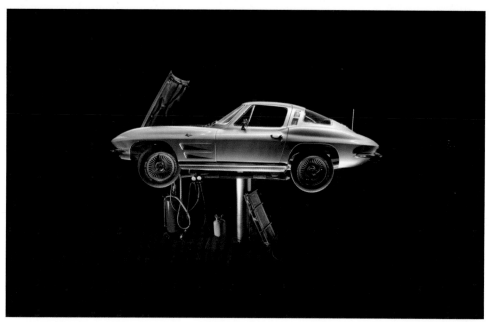

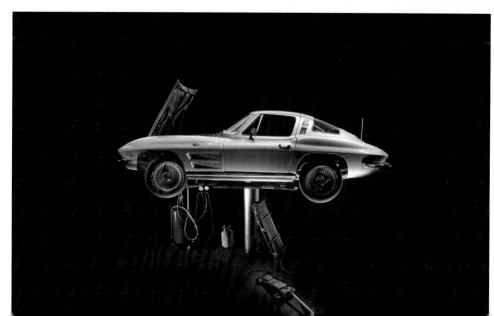

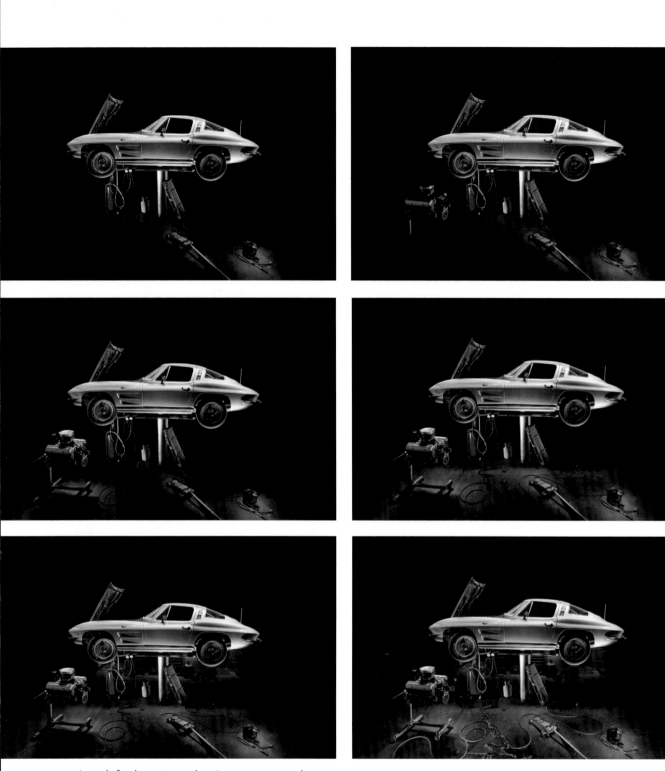

I work farther outward as I expose more shots.

After the main
subject and
its local area
are exposed,
I'll move on to
the remaining
environment.

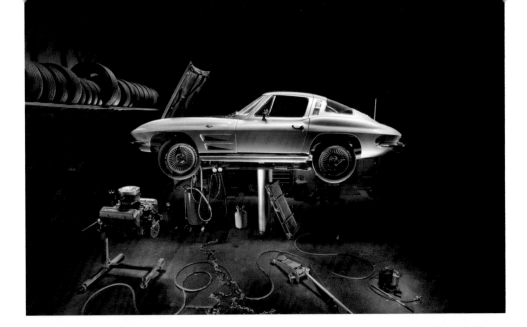

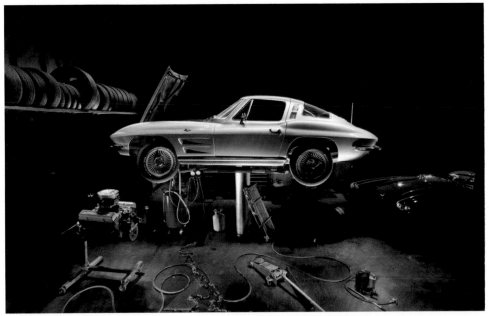

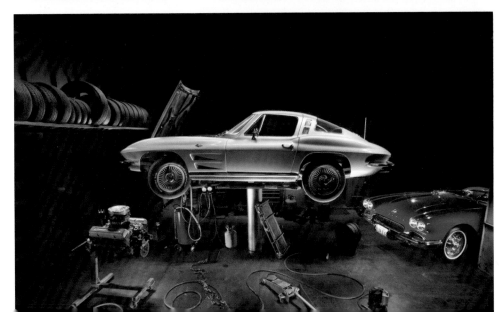

I include the walls, ceilings, and all the existing lights
from the environment outside.

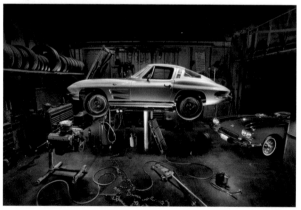

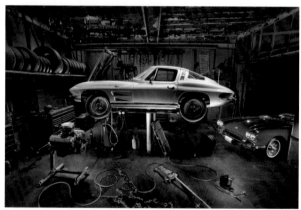

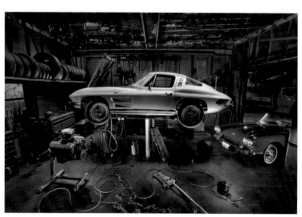

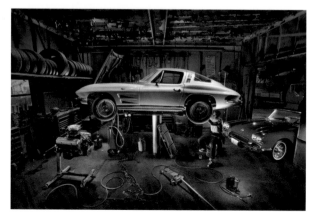

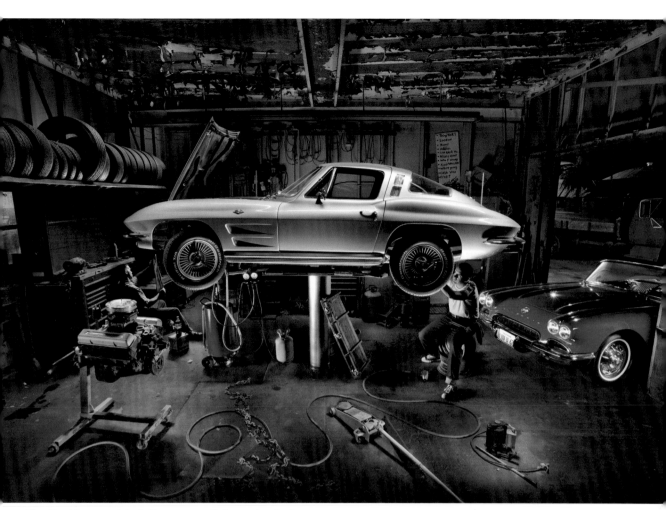

The final image, titled *Corvette, a Coke and a Smile.*

Yellow Submarine

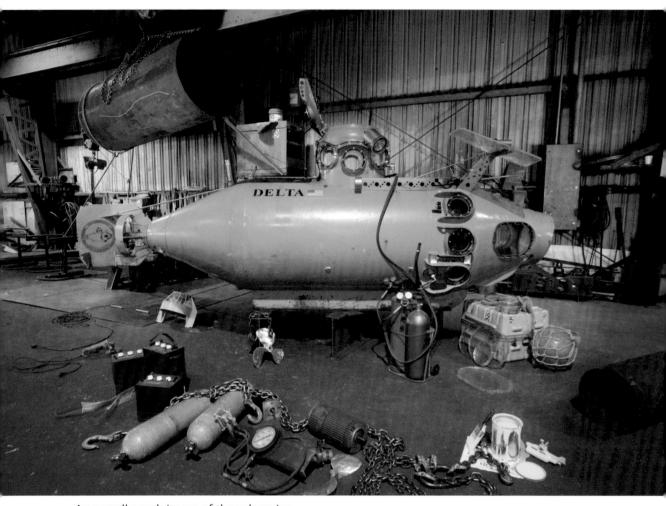

An overall rough image of the submarine.

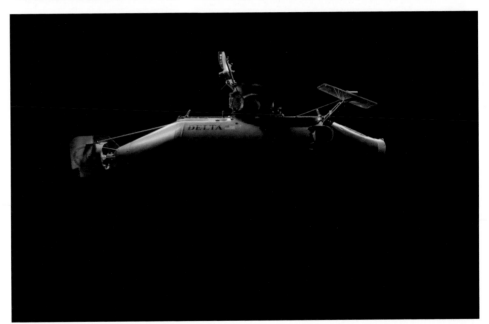

I started from the top center, then worked down. I was trying to create an almost iconic look for this miniature submarine.

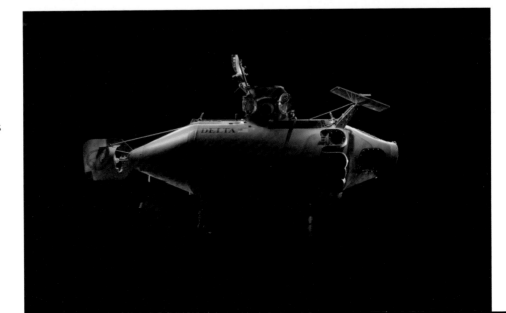

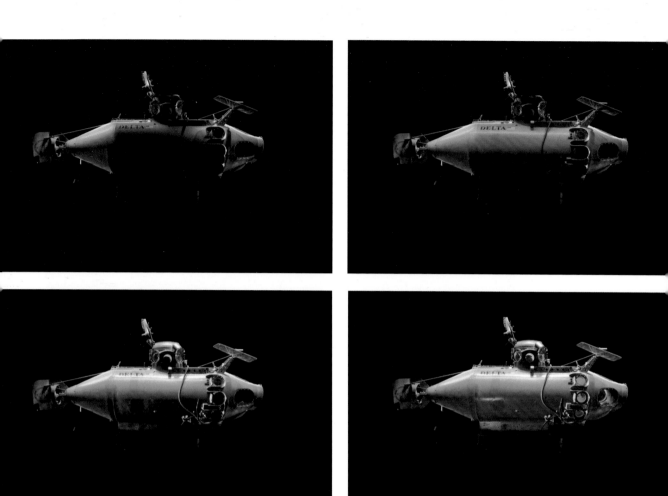

I continue working down the sides of the submarine.

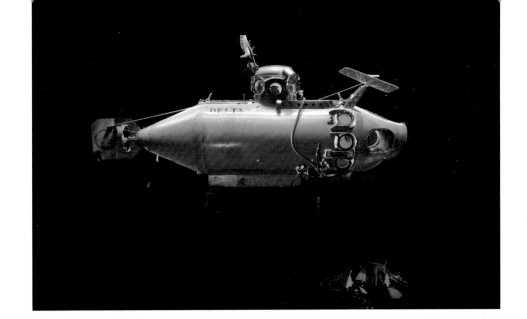

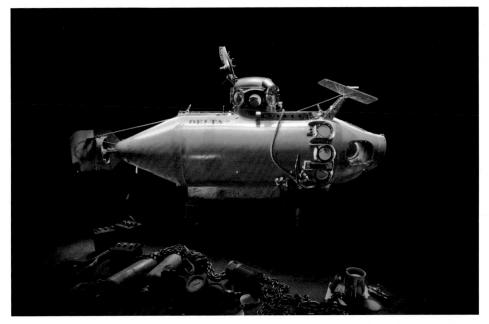

Here, I'm building
my lighting
out farther to
include the local
environment with
pools of light from
my floods and
skimming tools.

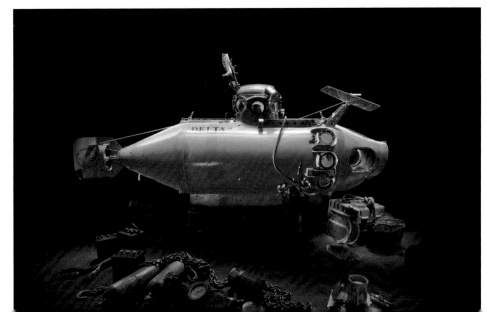

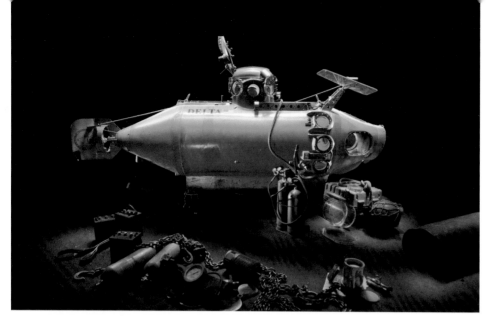

Using lighting, I am creating an interesting and beautiful scene that needs to be discovered and explored by the viewer.

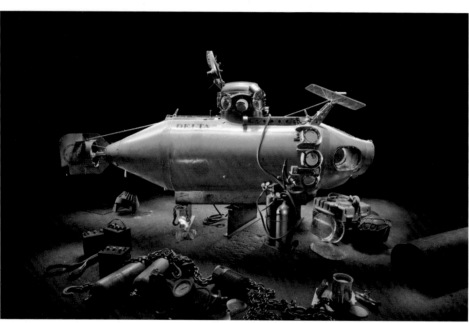

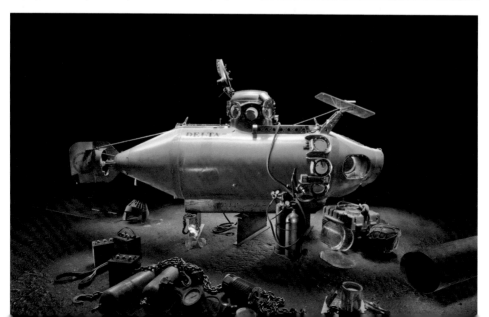

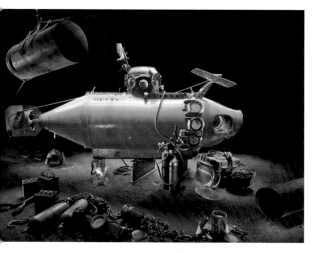

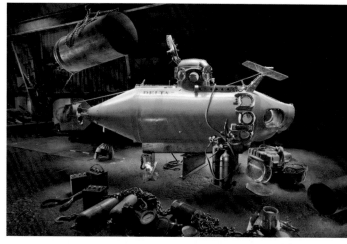

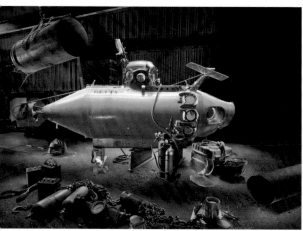

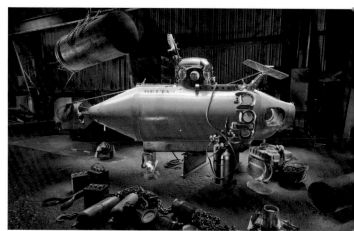

Next, I painted the rest of the environment, always conscious of the story I was trying to tell.

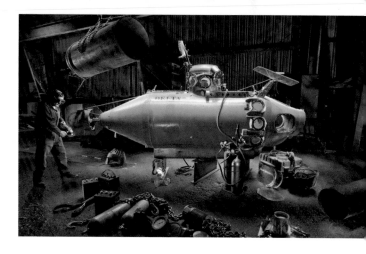

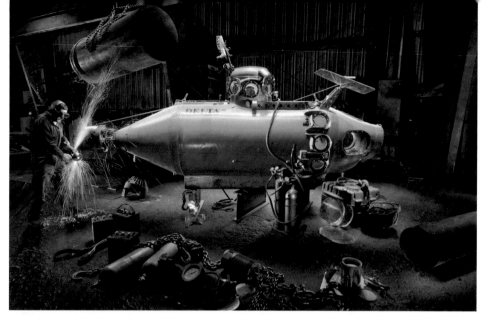

I did not want the lighting on the factory to be so interesting or overpowering that it detracted from the submarine. The lighting in these areas was designed to support the sub—like pancakes are a vehicle for maple syrup!

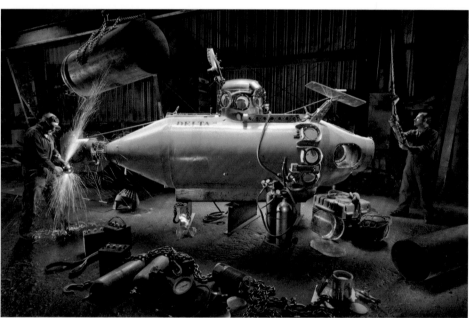

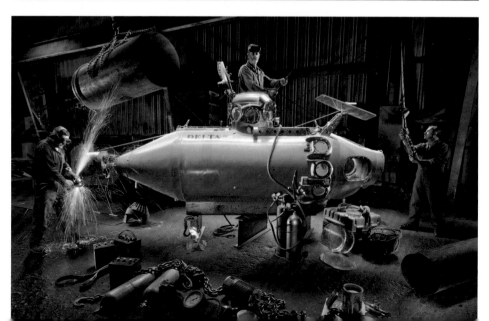

The final image, titled *Dive! Dive! Dive!*

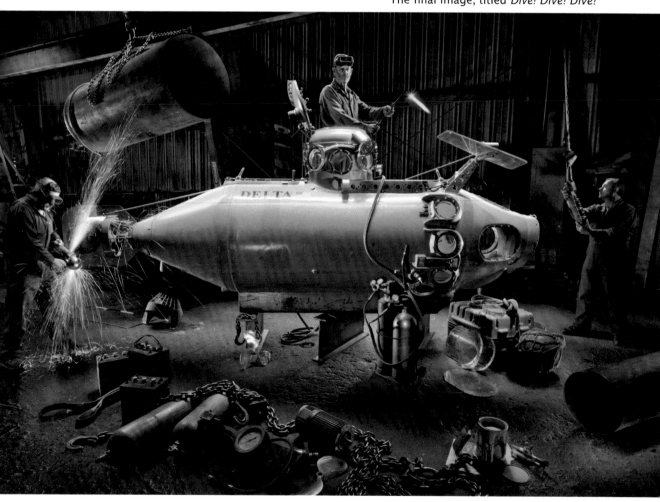

Airstream Trailer

I started with an exposure or two of the sunset, then built upon that wonderful image by painting the trailer after it was completely dark. The pool of light surrounding the trailer came from lighting the trailer's sides.

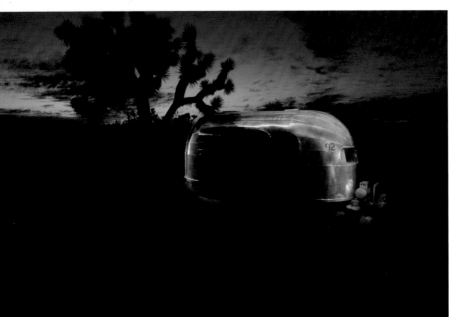

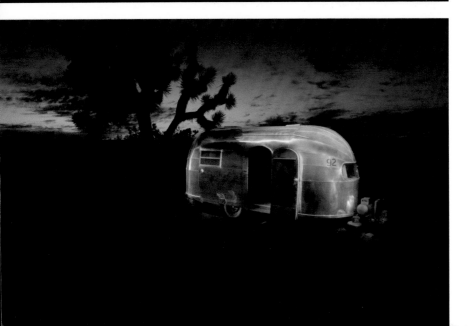

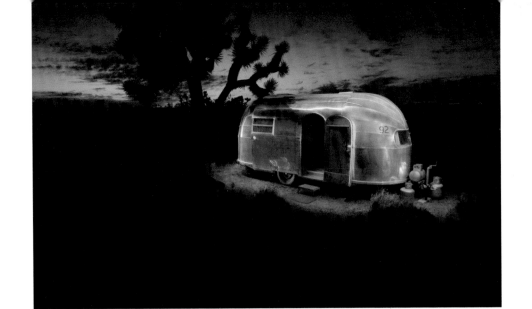

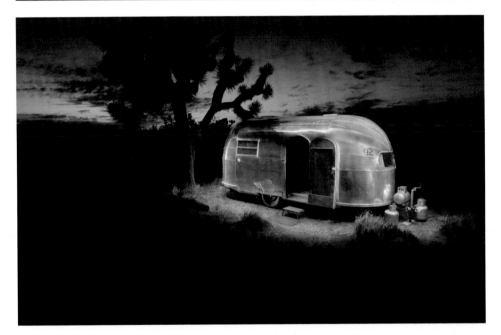

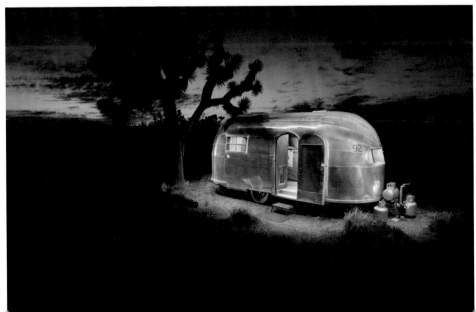

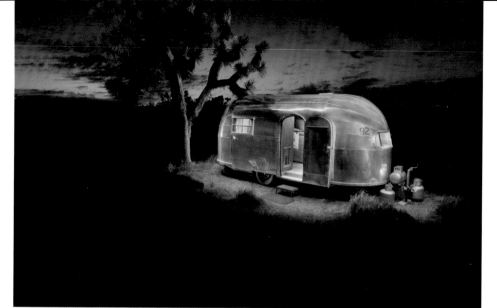

Finishing the shot, I included not only the environment but also the inside of the trailer. I also added light streaming out of the trailer door onto the ground.

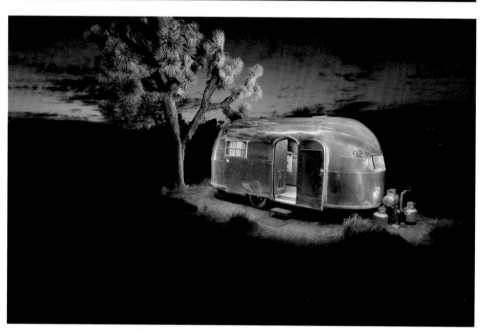

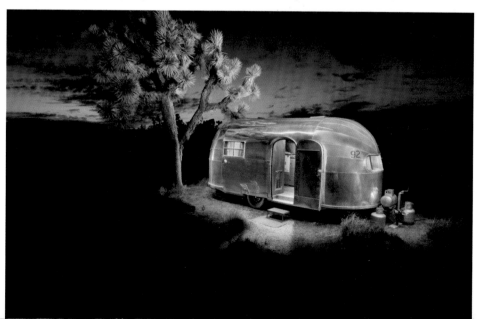

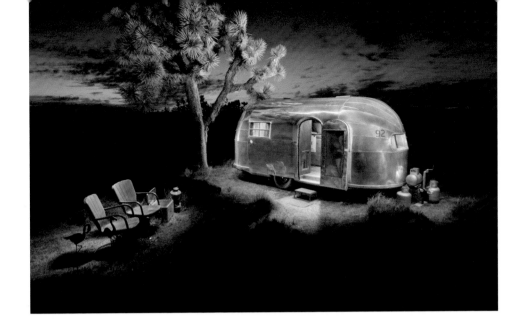

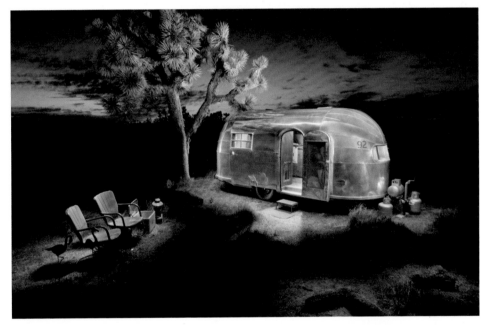

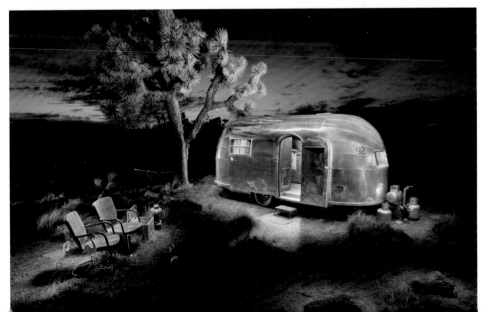

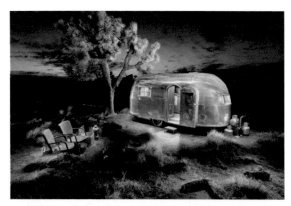

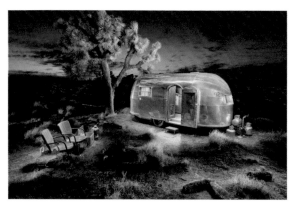

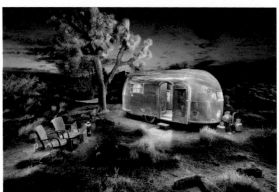

Notice the reflection of the Joshua Tree on the shiny top skin of the trailer—and, of course, the effects of the fire light on the environment and trailer skin. These were essentially happy accidents I was able to capitalize on in postproduction.

The final image, titled *Airstream Trailer & Home on the Range.*

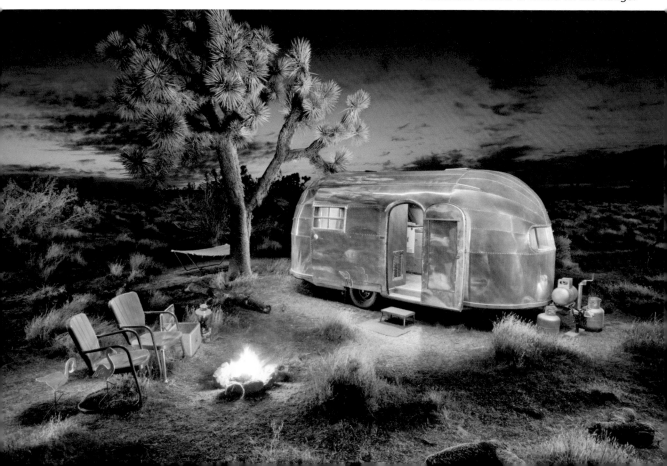

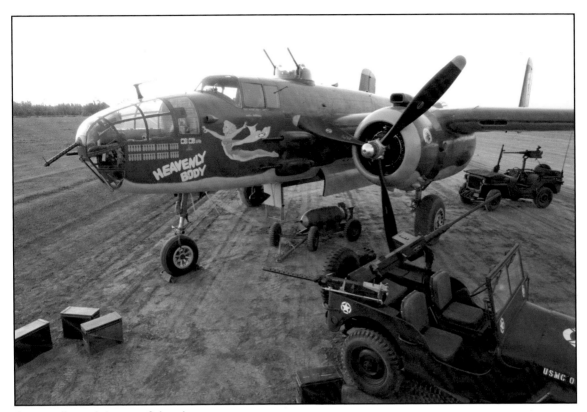

An overall rough image of the plane.

I began the composition with views after sunset.

I continued with views after sunset, then began to build up my main subject.

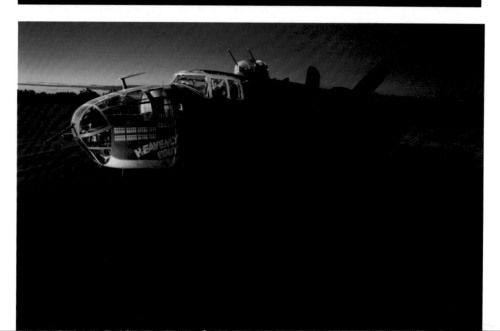

I continued to build up my main subject, working methodically across its surface.

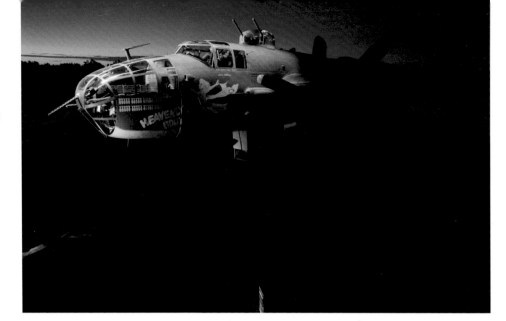

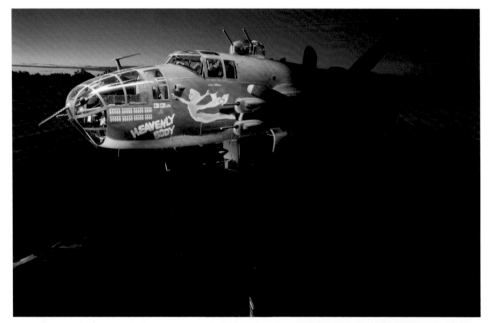

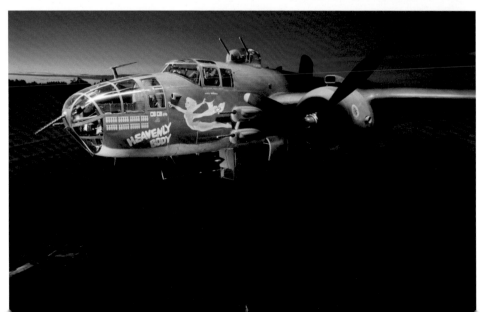

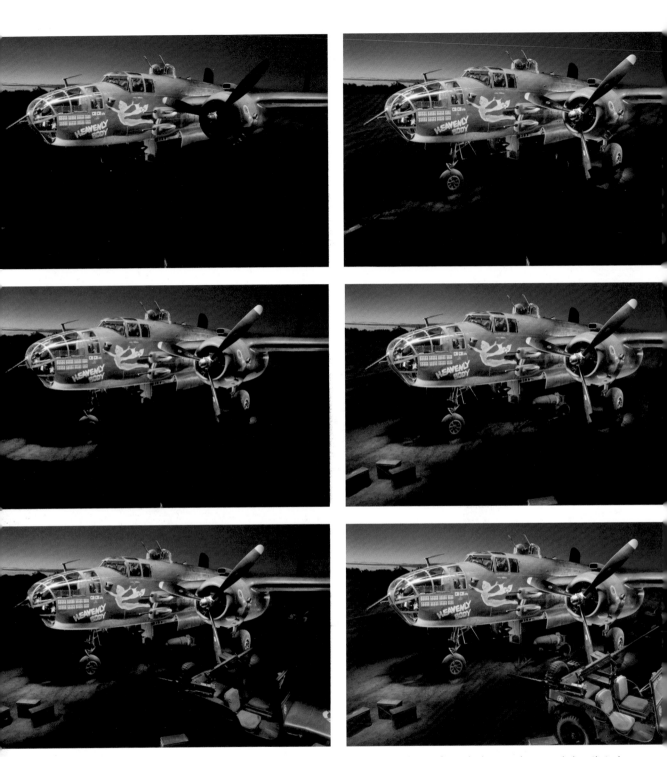

After the top and sides of my subject were finished, I added lighting from below and ground detail. I also lit all the other objects in the scene, like the Jeeps and ammunition boxes, along with their appropriate shadows and reflections.

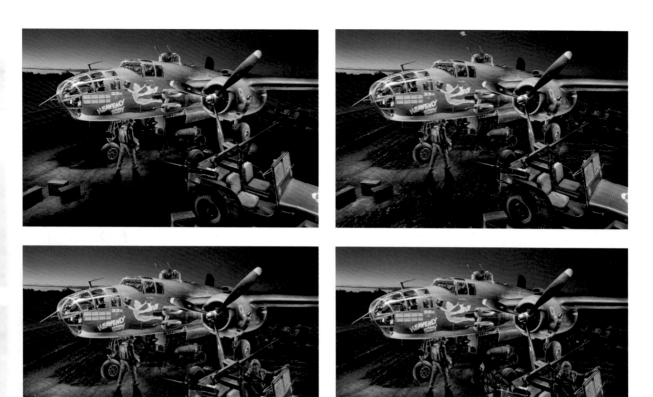

To complete the shot, I added the people and dog to give the final photo a warmth that only living subjects can add.

The final image, titled *B-25, Bomber Crew Plus One.*

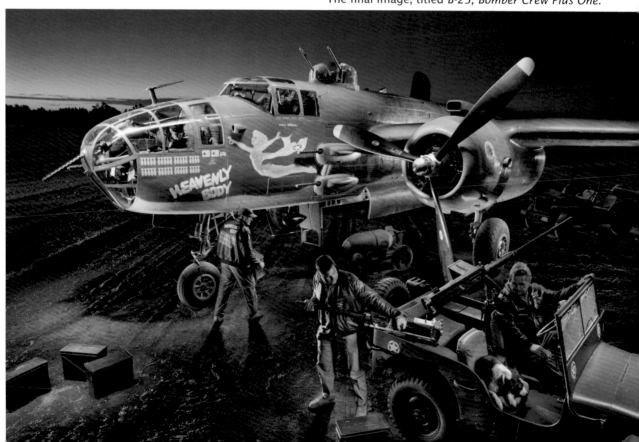

Conclusion

The virtues I value most in my own creative endeavors are persistence and attitude. Some artists are blessed with an innate ability to draw or paint, others have the god-given talent of music or the ability to write prose. Still others can intuitively create works of art seemingly unaided by formal education or training. I had none of those embedded talents. For myself, I was blessed with a passion for photography; the creativity and skill flowed from my desire to learn, develop, and enjoy my particular passion—along with a positive attitude.

For you, whether you're an amateur shooter or a seasoned professional, I'd like to offer this insight into our shared passion of photography. After you have gotten past the simple mechanics of painting with light, I'd like to suggest that you think in terms of ideas. Do not simply strive to make pretty photos of objects; instead, endeavor to create full and rich scenes that tell stories. The story you envision might be very simple, but when you add a theme, your photos will excel because of the underlying message being imparted to the viewer.

In life, I have found that practice does produce results. Practically speaking, start off with a simple test: shoot three frames with a flashlight in your living room tonight, then combine those images back together. You will learn volumes from that simple trial shoot. After that very first baby step, you too will be in a position to start conceptualizing a photo long before you expose the individual frames.

A Quick-and-Dirty Review

1. In a dark environment, set your camera on a tripod.

2. Using the camera's timer, expose a frame for about 12 seconds while you paint light from your hand-held flashlight onto one side of a subject.

3. Shoot a new exposure of about 12 seconds, this time painting onto the opposite side of that same subject.

4. Repeat steps 2 and 3 a few times.

5. In Photoshop open one image, then make the layers palette visible (Window>Layers).

6. Open a different image from the shooting session and drag it into the first image. You now have two layers.

7. In the layers menu, change the blending mode of the top layer to "lighten."

8. Erase any part of the top layer that does not fit the combined photo.

9. Repeat steps 6, 7, and 8 to add as many new layers/ exposures as you like.

10. Flatten the image.

Index

A

Adobe Bridge, 118
Adobe Photoshop, 23, 26, 116–29
Advertising images, 10–14
Airstream shoot, 146–50
Aperture, 63–64
Apple Aperture, 118

B

Batteries, 35, 40
Bomber shoot, 151–55

C

Cable release, 39
Camera requirements, 28–29
 manual focus, 29
 manual shutter, 28
 manual white balance, 29
 optical viewfinder, 29
Camera settings, 29, 60–65
 aperture, 63–64
 file format, 62–63
 focus, 29, 64–65
 ISO, 63
 noise reduction, 60
 white balance, 29, 60–62

Comfort on the shoot, 44
Corvette shoot, 130–37

D

Diffusion material, 37
DVD player, portable, 40–42

E

Existing light, 69, 105–6
Exposure time, 20, 70–76
Extension cords, 43–44

F

File formats, 62–63
Filters, Photoshop, 26
Focus, 29, 64–65
 locking, 64
 manual, 29
 setting, 64–65
Fogging, 22

H

HDR, 26
History of photography, 16–18
Human subjects, adding, 109–16, 126–29

(Human subjects, adding, cont'd)
 balancing with scene, 129
 challenges of, 109–10
 choosing best exposures, 127
 lighting, 113–16
 lighting with strobes, 115–16
 posing stability, 110–13
 postproduction techniques, 126–29

I

ISO setting, 63

L

Laptop, 40–42
Lens selection, 29–33
Lighting equipment, 33–38, 42–43, 45
 diffusion material, 37
 flashlights, 33–35
 for larger scenes, 34–37
 for smaller scenes, 33–34
 Lowel Pro, 36
 painter's pole, 36, 42–43

(Lighting equipment, cont'd)
 snoots, 37
 theatrical lights, 36
 wireless flash, 45
Lighting techniques, 78–106,
 113–16
 existing light,
 incorporating, 105–6
 for overall scene, 85–88
 for subject, 98–105
 hard *vs.* soft light, 89–98
 human subjects, 113–16
 planning, 79–80
 positioning the light, 88–89
 trying variations, 81–84
 working in sections, 81
Location selection, 46–53
 horizon line, 47
 light level, existing, 50–53
 optimal characteristics,
 49–50
 permission of owner, 53–55
Logistics of the shoot, 44–45

M
Model release, 56

N
Night photography,
 traditional, 18–20
Noise reduction, 60

P
Painter's poles (light support),
 36, 42–43
Painting with light, 14–16,
 20–25
 multiple-exposure
 approach, 23–25,
 28–115
 professional applications
 for, 14–16
 single-exposure approach,
 20–23
Plugs, 43–44
Postproduction, 116, 117–29
 background layer, choosing,
 120
 background layer,
 unlocking, 121
 blending modes, 124–25,
 128
 brush settings, 123
 choosing images, 118
 Eraser tool, 121–23
 layers, adding, 121–25
 layers, aligning, 123,
 128–29
 reconstructing human
 subjects, 126–29
 Snap function, 123
Property release, 55

S
Sandbags, 38
Scouting, *see* Location
 selection
Setup for shoot, 57–59
Shooting process, 66–70
Shutter, manual mode, 28
Shutter operation, 76
Snoots, 37
Strobes, lighting human
 subjects with, 115–16
Subject selection, 49
Submarine shoot, 138–45
Sunset, photographing, 69
Switches, 43–44

T
Tripods, 20, 38–39, 66

V
Viewfinder, 29

W
White balance, 29

OTHER BOOKS FROM
Amherst Media®

Flash Techniques for Location Portraiture

Alyn Stafford takes flash on the road, showing you how to achieve big results with these small systems. *$39.95 list, 7.5x10, 160p, 220 color images, order no. 1963.*

LED Lighting: PROFESSIONAL TECHNIQUES
FOR DIGITAL PHOTOGRAPHERS

Kirk Tuck's comprehensive look at LED lighting reveals the ins-and-outs of the technology and shows how to put it to great use. *$34.95 list, 7.5x10, 160p, 380 color images, order no. 1958.*

Lighting for Architectural Photography

John Siskin teaches you how to work with strobe and ambient light to capture rich, textural images your clients will love. *$34.95 list, 7.5x10, 160p, 180 color images, index, order no. 1955.*

FLASH TECHNIQUES FOR
Macro and Close-up Photography

Rod and Robin Deutschmann teach you the skills you need to create beautifully lit images that transcend our daily vision of the world. *$34.95 list, 8.5x11, 128p, 300 color images, index, order no. 1938.*

UNLEASHING THE RAW POWER OF
Adobe® Camera Raw®

Mark Chen teaches you how to perfect your files for unprecedented results. *$34.95 list, 8.5x11, 128p, 100 color images, 100 screen shots, index, order no. 1925.*

Master Lighting Guide
FOR COMMERCIAL PHOTOGRAPHERS

Robert Morrissey outlines the tools and techniques pros rely on to win corporate clients and meet challenges. *$34.95 list, 8.5x11, 128p, 110 color photos, 125 diagrams, index, order no. 1833.*

Commercial Photography Handbook

Kirk Tuck shows you how to identify, market to, and satisfy your target markets—and maximize profits. *$34.95 list, 8.5x11, 128p, 110 color images, index, order no. 1890.*

Lighting Essentials: LIGHTING FOR
TEXTURE, CONTRAST, AND DIMENSION

Don Giannatti explores lighting to define shape, conceal or emphasize texture, and enhance the feeling of a third dimension. *$34.95 list, 7.5x10, 160p, 220 color images, order no. 1961.*